HAND-LETTERED
HOME

DIY Wood Signs *for* Farmhouse Decor

CAROLINE BRYAN

CASTLE POINT BOOKS
NEW YORK

FOR MIKE,
WITH LOVE

ISBN 978-1-250-27064-1 (hardcover)
ISBN 978-1-250-27065-8 (ebook)

Design by Joanna Williams

Photography and lettering art by Caroline Bryan except images on pages
1, 2, 53, 54 (bottom), 55-57, 58 (top), 59-61, 63 (bottom), 69, 86 (room), 112 (room),
116, 154 (room), 158 (room) used under license from Shutterstock.com

Our books may be purchased in bulk for promotional, educational, or business
use. Please contact your local bookseller or the Macmillan Corporate and
Premium Sales Department at 1-800-221-7945, extension 5442, or by email
at MacmillanSpecialMarkets@macmillan.com.

First Edition: 2020

10 9 8 7 6 5 4 3 2 1

CONTENTS

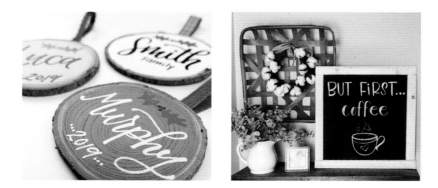

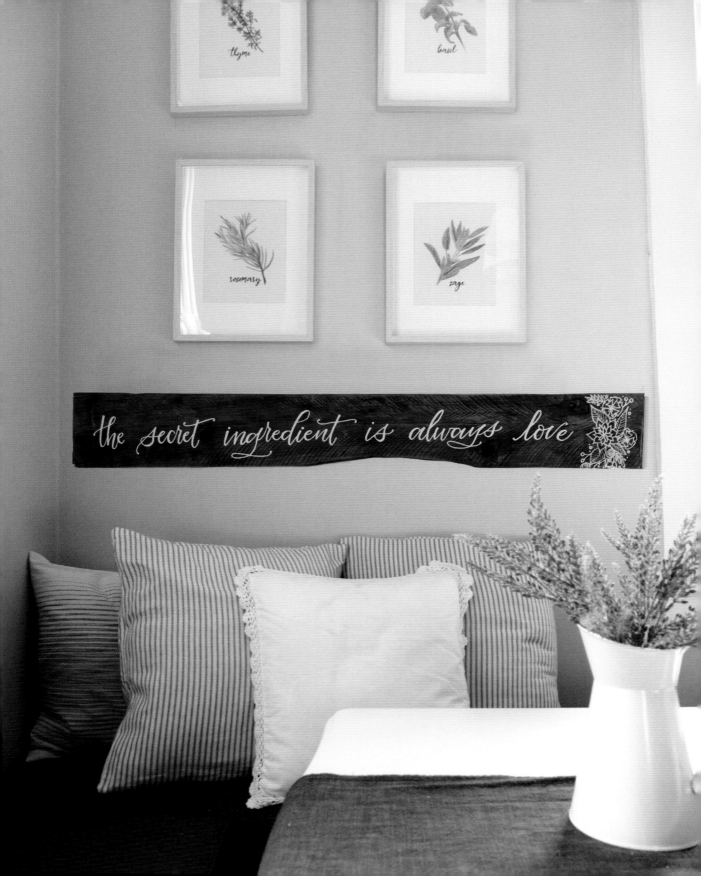

WELCOME

Do you gravitate toward the decor signs in home stores, just like me? I love exploring the words, flourishes, finishes, and textures. Most of all, I love the warmth and meaning that a well-made sign can add to a home. But still, I'm often left disappointed at the choices—maybe the colors don't coordinate with my design or the standard size doesn't fit my space well. Often, the cost isn't within my budget. The beautiful solution: DIY hand-lettered signs.

I can make a one-of-a-kind piece of affordable art for my home exactly as I want—in the size, color, and finish that I need for my space. And you can too, with the step-by-step tips and design ideas in *Hand-Lettered Home*! In the pages that follow, you'll find 20 sweet signs to add warmth, whimsy, and modern farmhouse style to every area of your home. Best of all, the lettering and wood techniques you learn through the designs are completely customizable to help you create signs that are uniquely yours. Each project is a starter path to endless design possibilities! Simply switch up any element you want— from the hand-lettering style to the wood finish to the paint pen color. The "Mix It Up" section at the end of each project gives you great variations to consider, but you don't need to stop there with inspired ideas that branch out from the original sign.

While you're decorating your own home with special meaning and memories, keep in mind that hand-lettered signs make amazing gifts. It is such a joy to be able to create wood signs for my own home as well as the homes of family, friends, and customers. I hope that you find the same joy and satisfaction in creating your own signs with *Hand-Lettered Home*!

Caroline Bryan

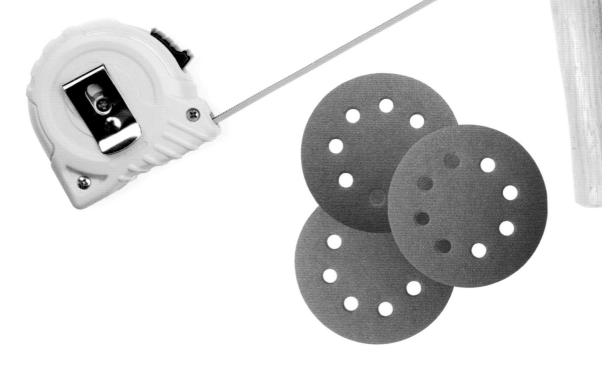

Visit me: instagram.com/carolettering • etsy.com/shop/carolettering

1

HAND LETTERING
MADE SIMPLE

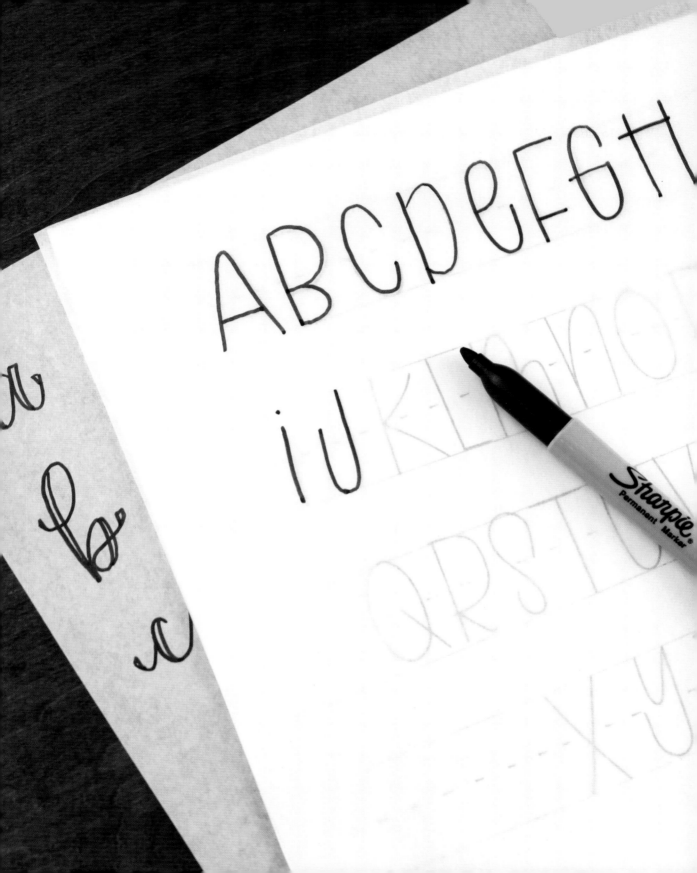

GETTING STARTED

To create the gorgeous hand-lettered signs in this book or any signs you dream up, you will need to get to know three basic but highly customizable lettering styles: Faux Calligraphy, a beautiful script; Block Print, a versatile serif* print; and Cafe Print, a lighthearted sans serif print. With these three lettering styles in your toolbox, you will be able to mix and match to create unique signs for every occasion and room in your home!

STEPS FOR THE BEST LETTERING

1. **PRACTICE BEFORE PAINTING.** Use the practice pages that follow to learn how to build letters (capitals and lowercase) and numbers in the three lettering styles. The more you practice, the more natural the process will feel and the smoother your lettering will become. Need a refresher as you work on signs? These pages will be here for you to revisit.

2. **USE TOOLS WISELY.** No matter how much you practice with these lettering pages, it's only natural to find yourself in a whole new scenario when you go from paper to sign. Suddenly, you've lost your guides to make sure your lettering is even. Fortunately, some simple tools can come to the rescue.

 - For beginners and experts at hand lettering alike, it's a smart idea to create a baseline guide. This basic but super-helpful step keeps all letters the same height and avoids the natural downward slant when we write. A ruler or painter's tape works well when writing Block or Cafe letters. Use a laser level guideline for Faux Calligraphy.

 - Remember that when you're ready to move your hand lettering onto a sign, chalk can be your best friend for creating lettering guides before you commit to paint.

3. **GO SLOWLY.** Your grocery list might be hardly legible, but that doesn't mean you can't learn to hand letter! Take your time and be deliberate about forming each letter—whether you're working on practice pages or have progressed to lettering on a sign. You'll appreciate the results.

*Wondering about serif versus sans serif lettering styles? A serif is a decorative line added to a letter's stem. So serif fonts have those lines (sometimes called "feet") while sans serif fonts don't. (Sans means "without" in French.)

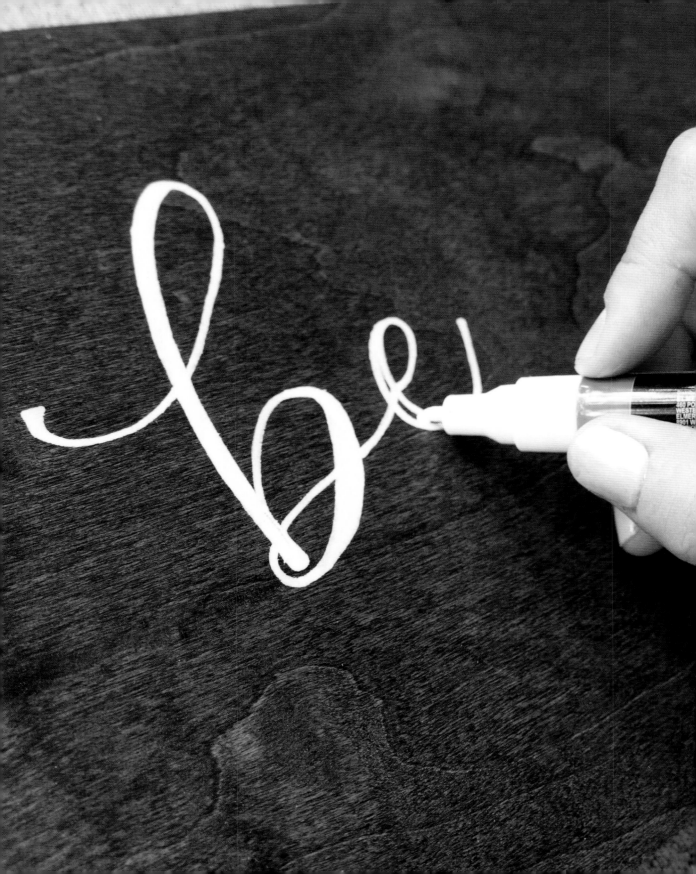

FAUX CALLIGRAPHY

Faux Calligraphy mimics the look of a calligraphy pen and nib, which allow a calligrapher to create different line weights depending on how much pressure is put on the pen. On the "upstrokes" of letters, the calligrapher uses hardly any pressure on the pen and the strokes are thin and light. However, on the "downstrokes" of letters, the calligrapher places pressure on the nib so more ink flows to the paper, creating a heavier line weight and a thick, dark stroke. In sign making, we mimic this look by going back over the letters to "double the downstrokes" with the paint pen. The upstrokes of letters are a single line of paint and look thin compared to the downstrokes of the letters, which are doubled and thicker. To vary the style, you can also stick with monoline Faux Calligraphy—simply a single line without doubled downstrokes.

You will notice in the following pages that I also add extra weight at the beginning and end strokes of letters to create "end caps." This style adds polish to large-scale lettering on a sign. Practice the end caps for each letter. When it is time to create words with the letters, simply drop the end caps where needed to connect letters.

Once you master a basic Faux Calligraphy alphabet, you have the option to alter the letters to create a signature style. I find that the three letters o, r, and s can be easily swapped for a slightly different look from the start. For this reason, you will find two ways to write each of those letters in the following practice pages.

DOUBLED DOWNSTROKES & END CAPS

Here's an example: Begin by drawing the letter with a single line. Mark the doubled down-strokes and add end caps. Fill in the down-strokes and end caps.

Buy a pack of tracing paper and lay the paper over this book for additional practice! Any bullet-tip pen or marker will work well as you are learning.

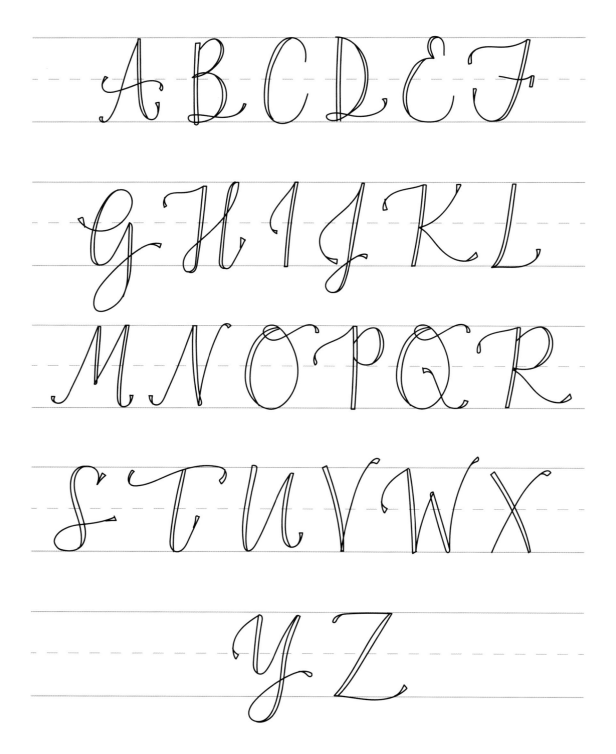

a b c d e f

g h i j k l

m n o p q

r s t u v w

x y z o r s

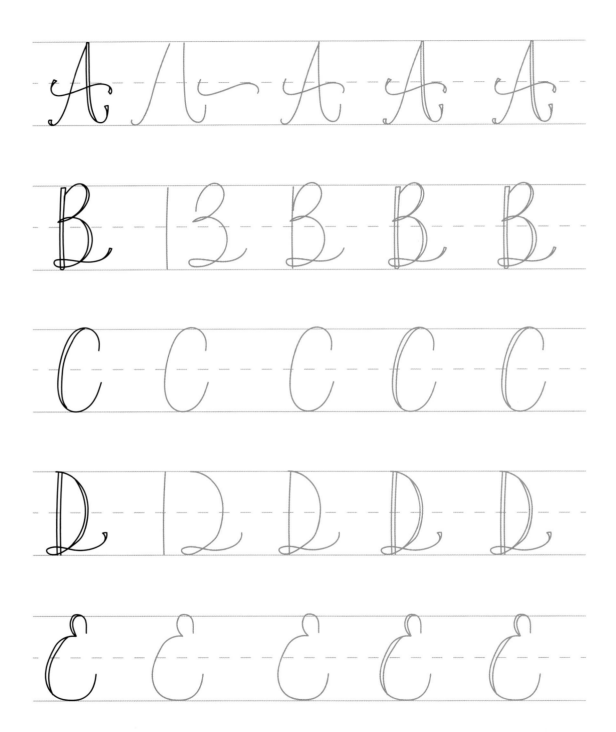

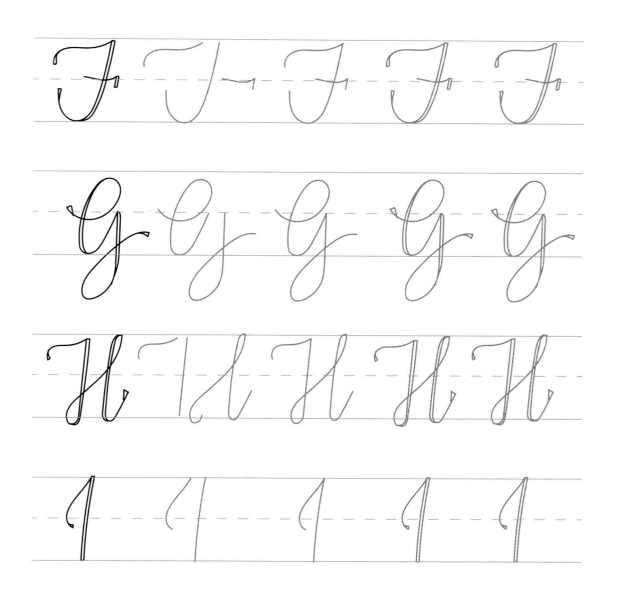

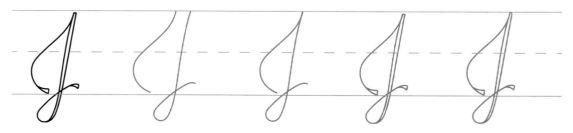

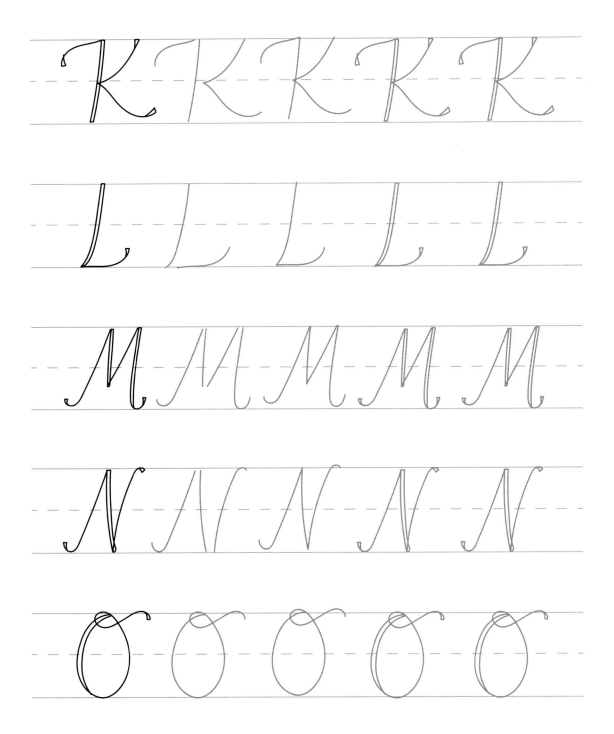

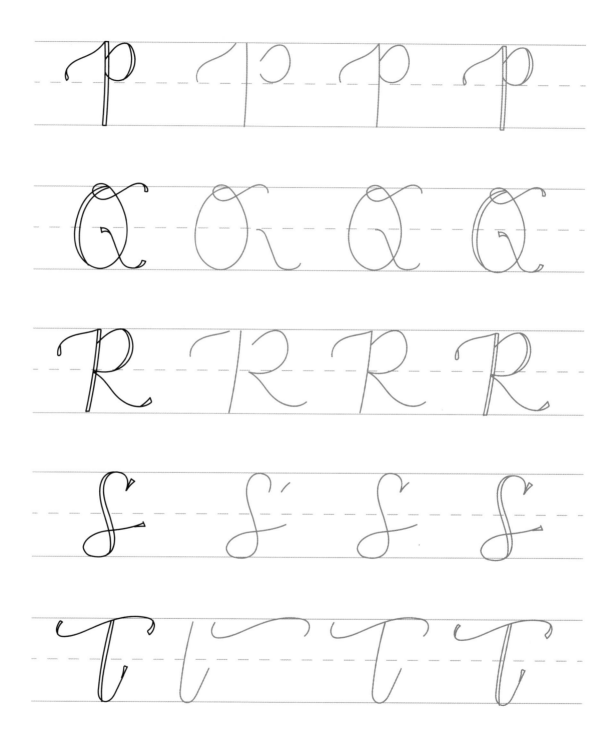

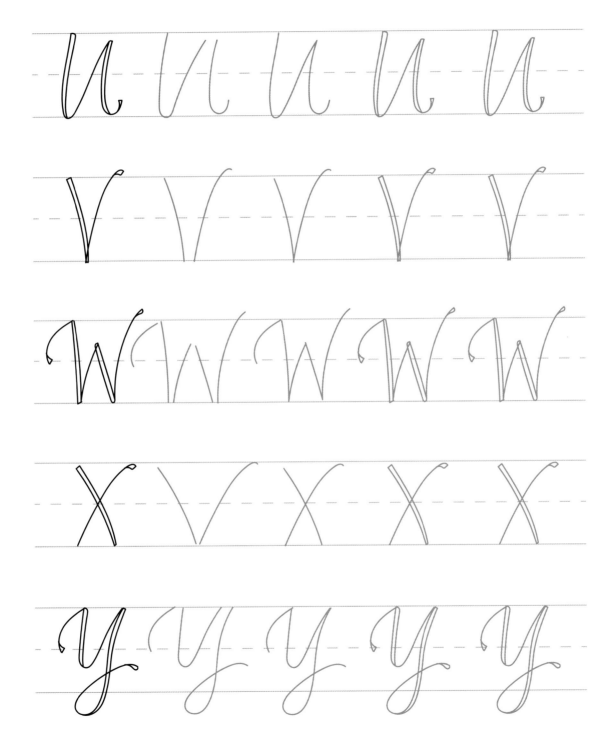

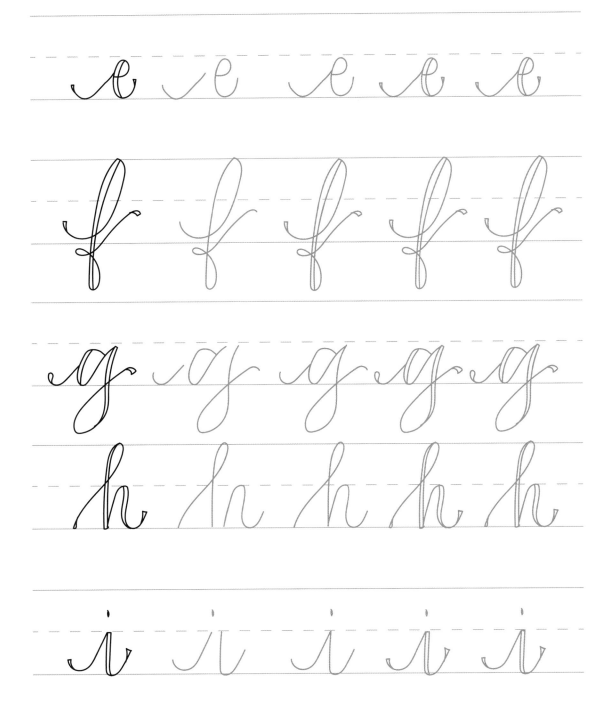

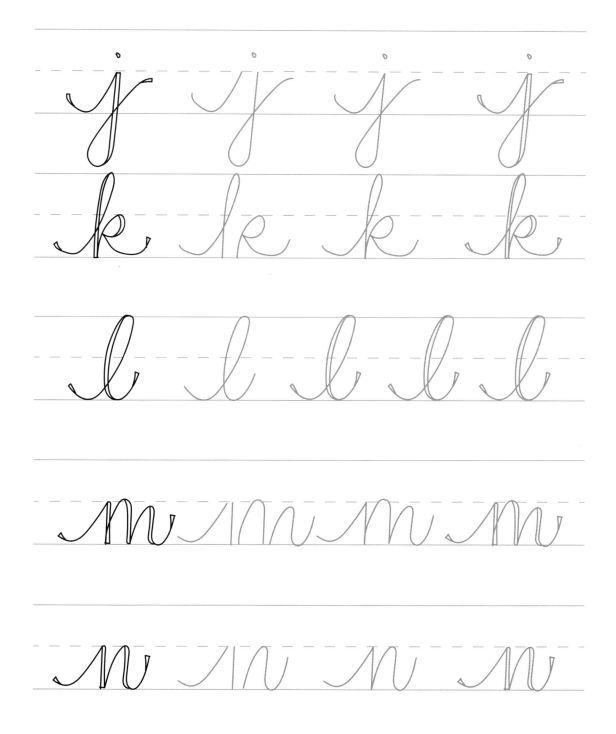

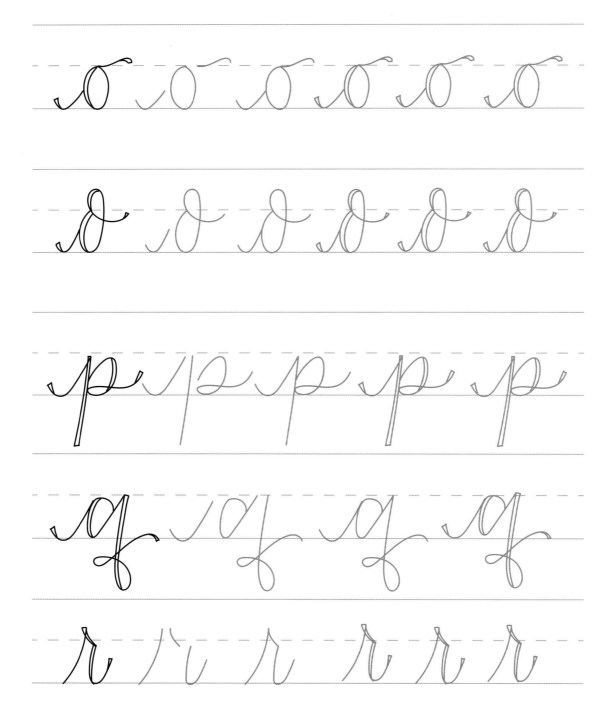

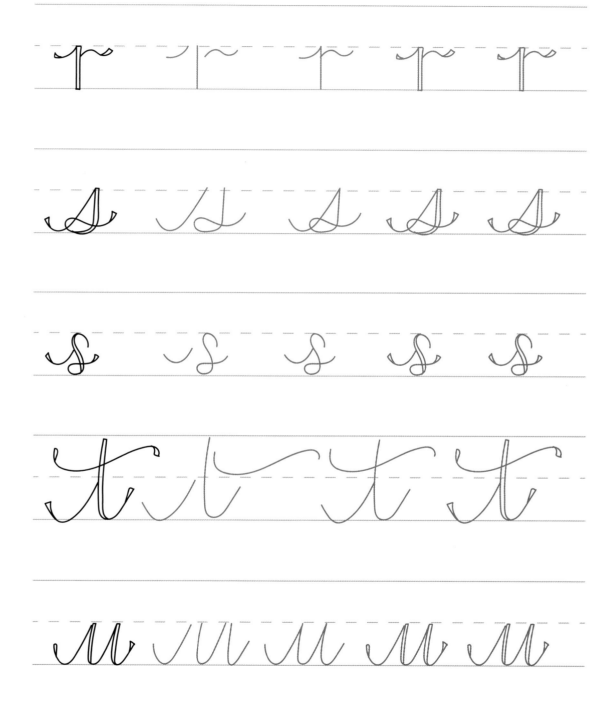

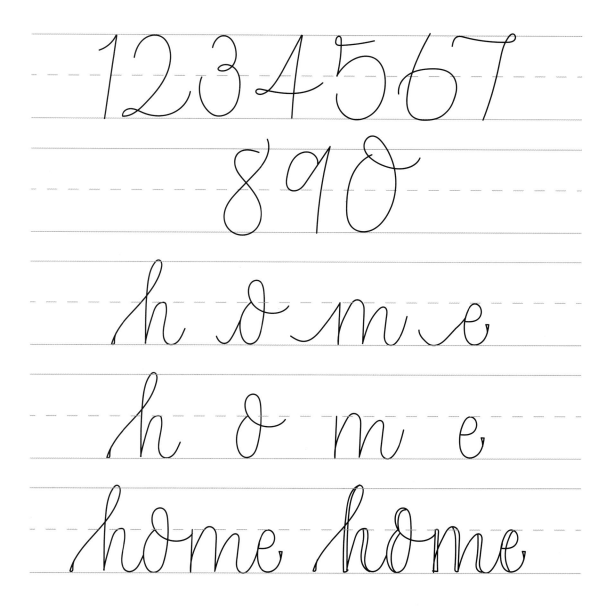

CONNECTING FAUX CALLIGRAPHY LETTERS TO CREATE WORDS

1. Remove all but the first and last end caps.

2. Remove lead-in stroke to the left of each letter.

3. Connect the letters.

4. Double the downstrokes.

BLOCK PRINT

Block Print is a versatile serif print style. It is sharp and neat but still has the charm of being hand lettered. Use a ruler or triangle to help keep lines straight and tidy. Painter's tape is also a great guide for keeping the letters the same size across the sign. This alphabet can easily be customized by filling in the letter or leaving it outlined.

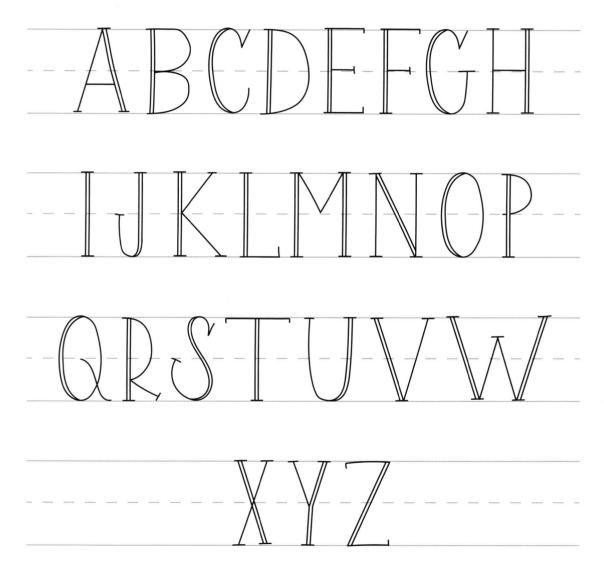

a b c d e f g h i

j k l m n o p q r

s t u v w x y z

Remember to use a ruler or triangle to keep your lines straight! See Block Print featured on page 132 in the My Favorite Place sign.

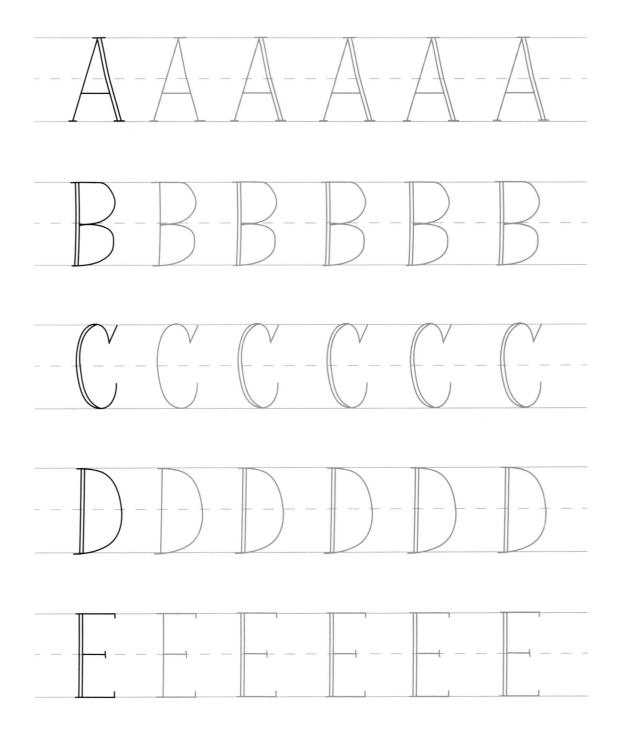

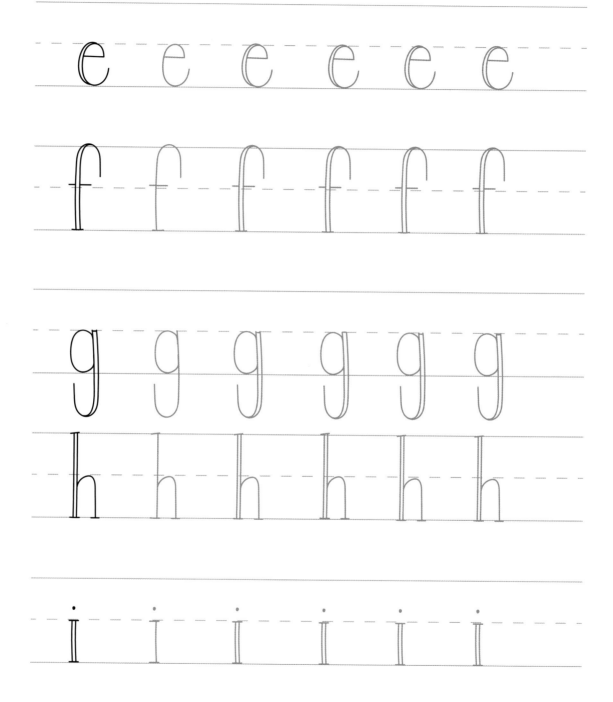

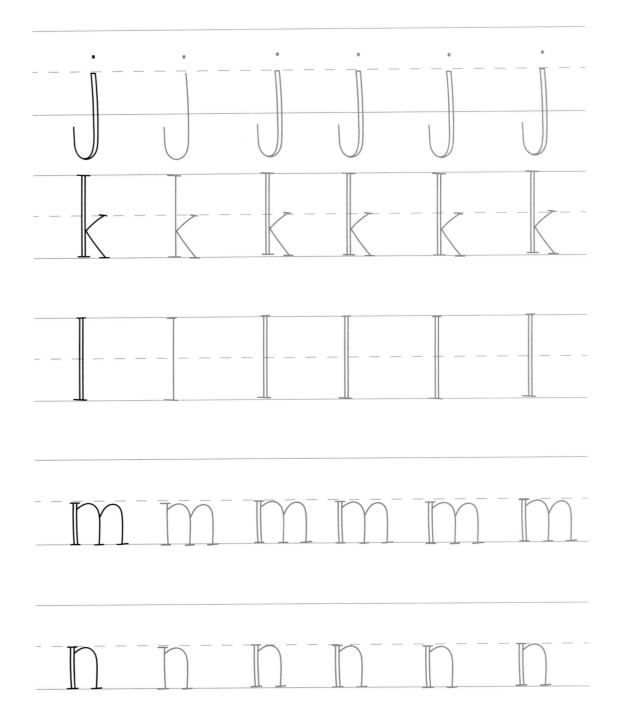

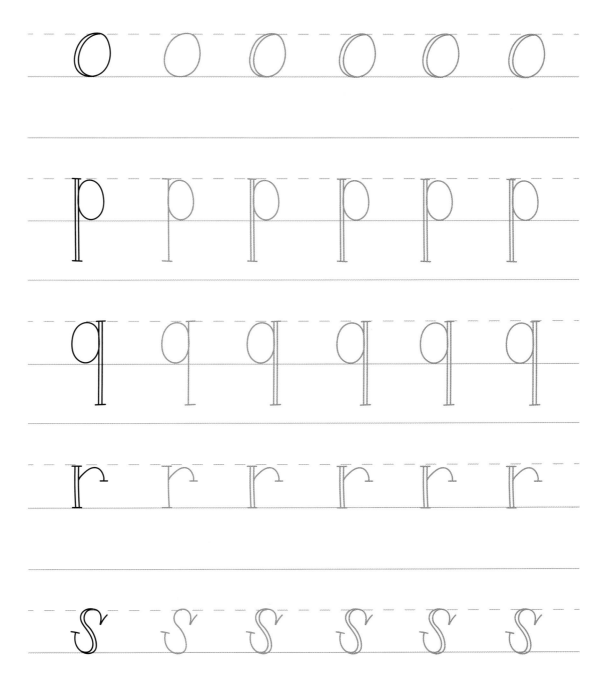

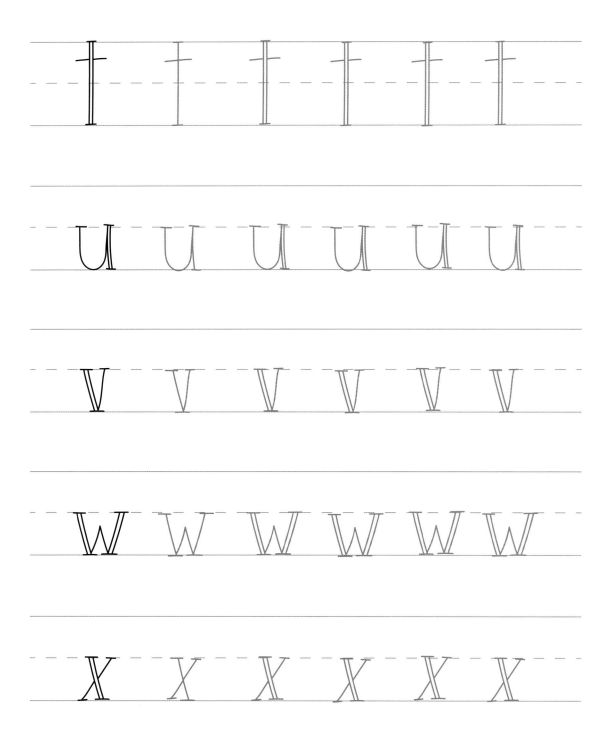

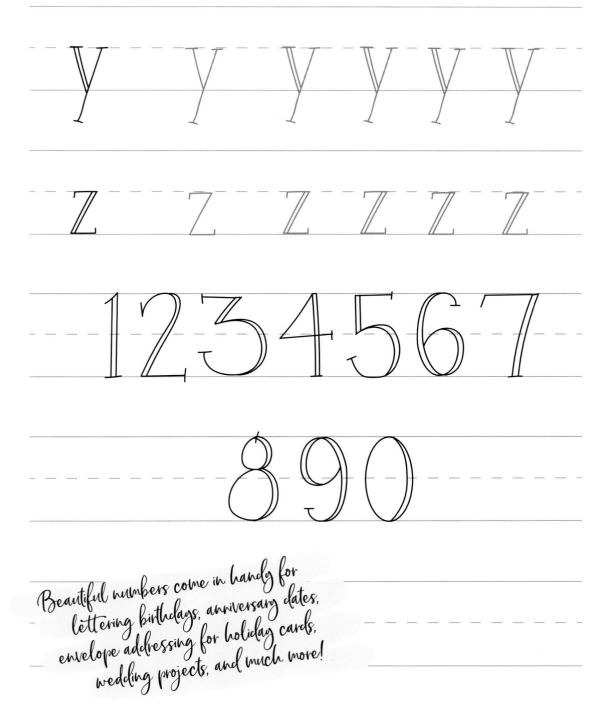

Y Y Y Y Y Y

Z Z Z Z Z Z

1 2 3 4 5 6 7

8 9 0

Beautiful numbers come in handy for lettering birthdays, anniversary dates, envelope addressing for holiday cards, wedding projects, and much more!

HOME

WELCOME

FAMILY

LOVE LOVE

LOVE love

CAFE PRINT

Cafe Print is a whimsical sans serif print style. It is playful and fun and looks great paired with another style or as stand-alone hand lettering. Just as with the Block Print style, using a ruler, triangle, or painter's tape will help keep letters consistent and level across a sign. Customize the Cafe Print letters by increasing the height of the letters or varying the width of the letters. Also try varying the line weight by using a thin Micron-type pen or a thick bullet-tip Sharpie pen.

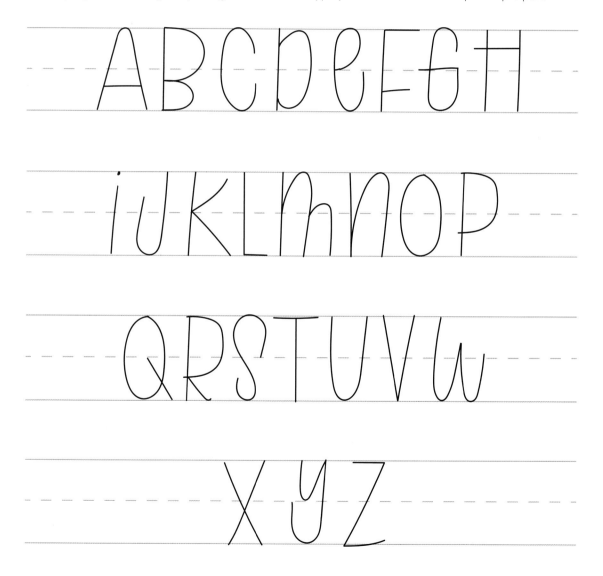

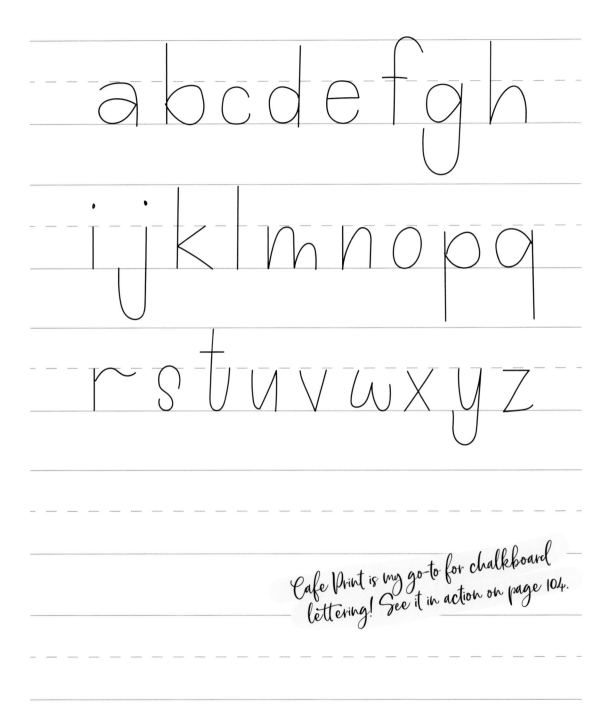

abcdefgh

ijklmnopq

rstuvwxyz

Cafe Print is my go-to for chalkboard lettering! See it in action on page 104.

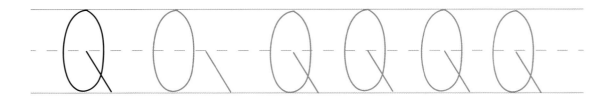

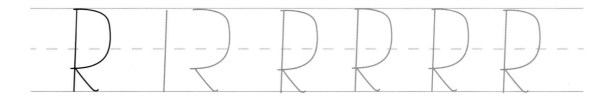

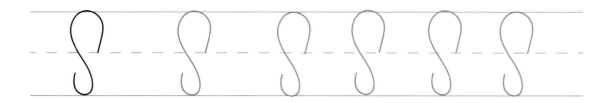

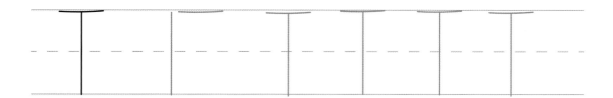

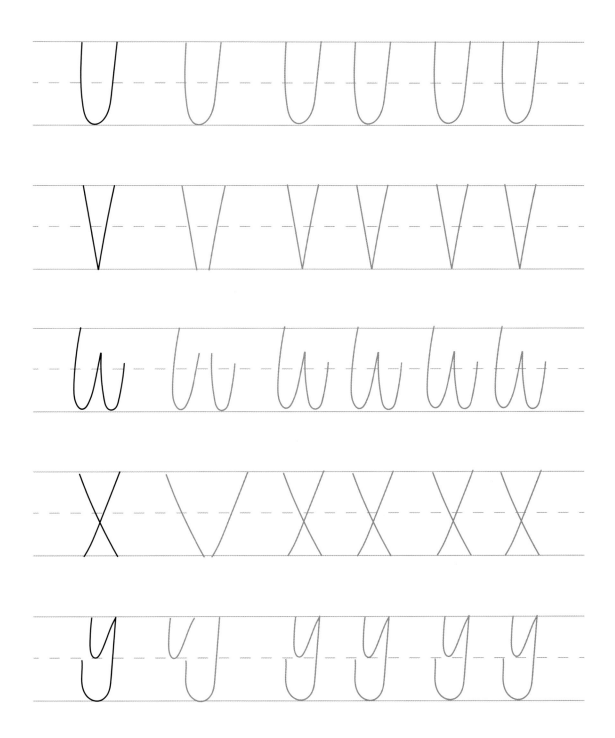

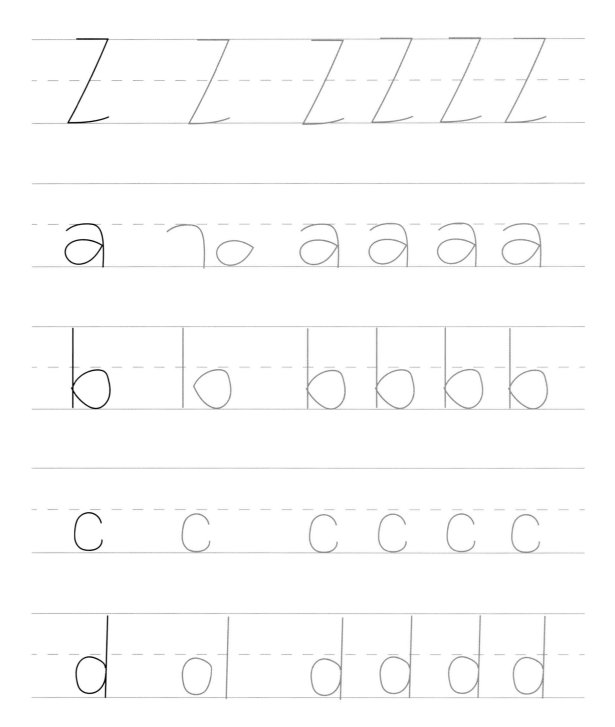

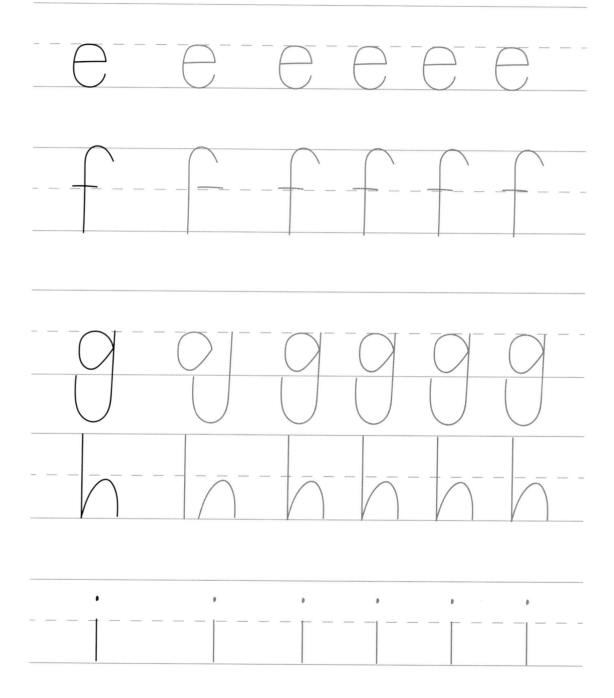

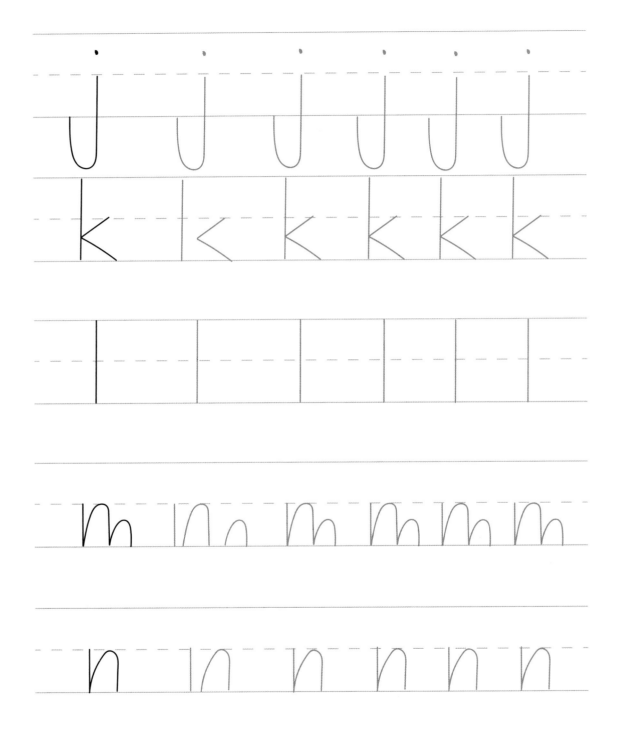

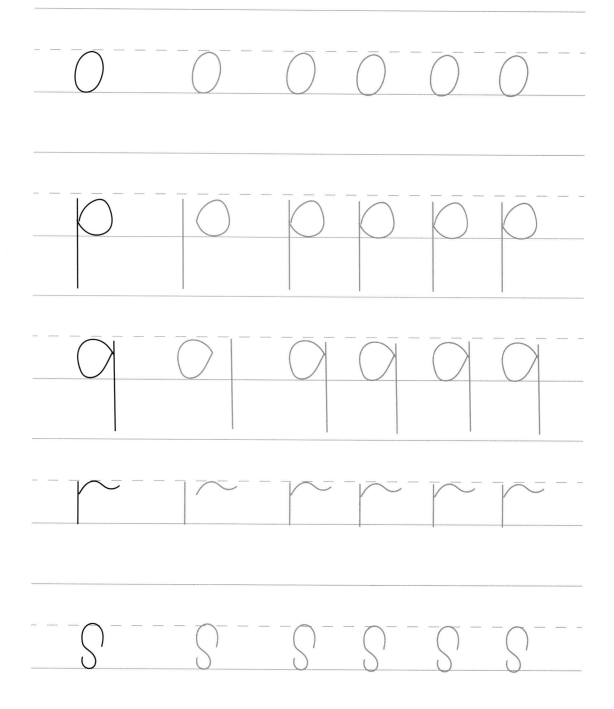

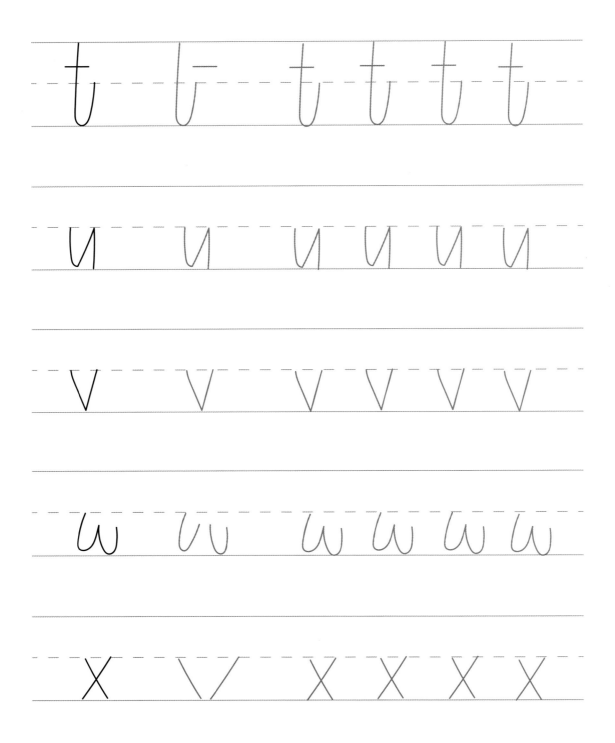

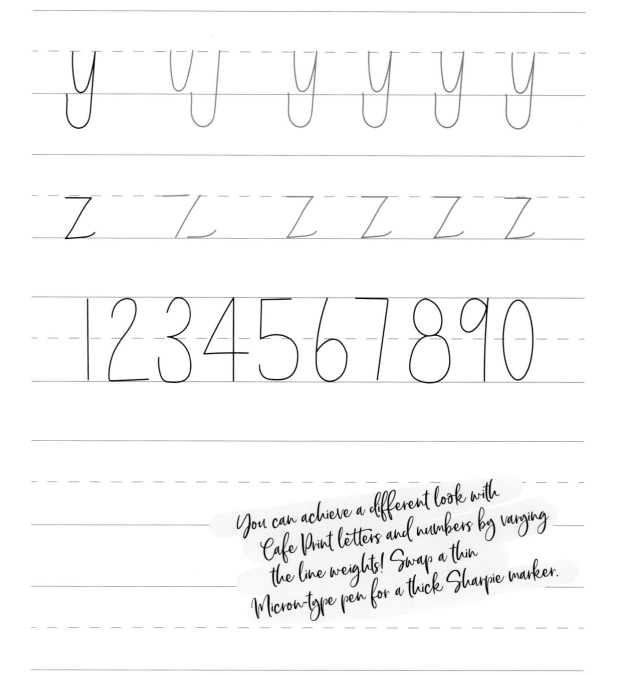

y y y y y y

z z z z z z

1234567890

You can achieve a different look with Cafe Print letters and numbers by varying the line weights! Swap a thin Micron-type pen for a thick Sharpie marker.

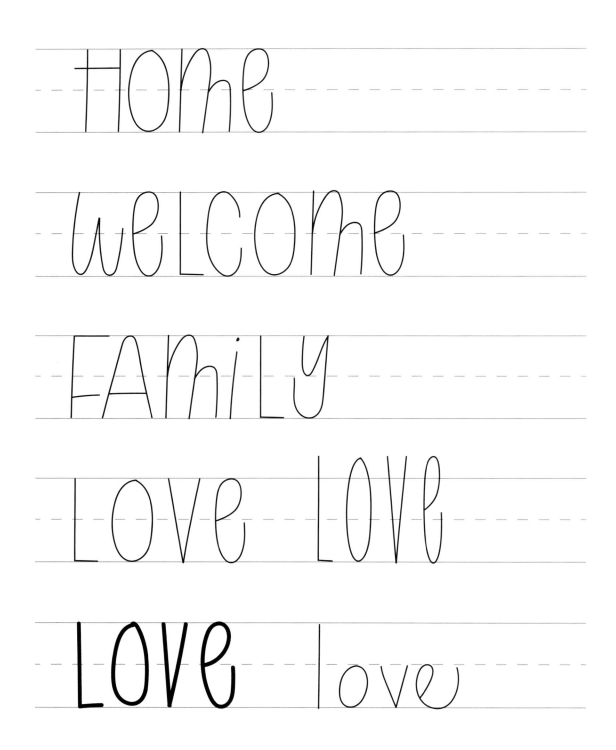

Home

welcome

FAmily

Love LOVe

LOVe love

SIGN SUPPLIES, TOOLS & PREP

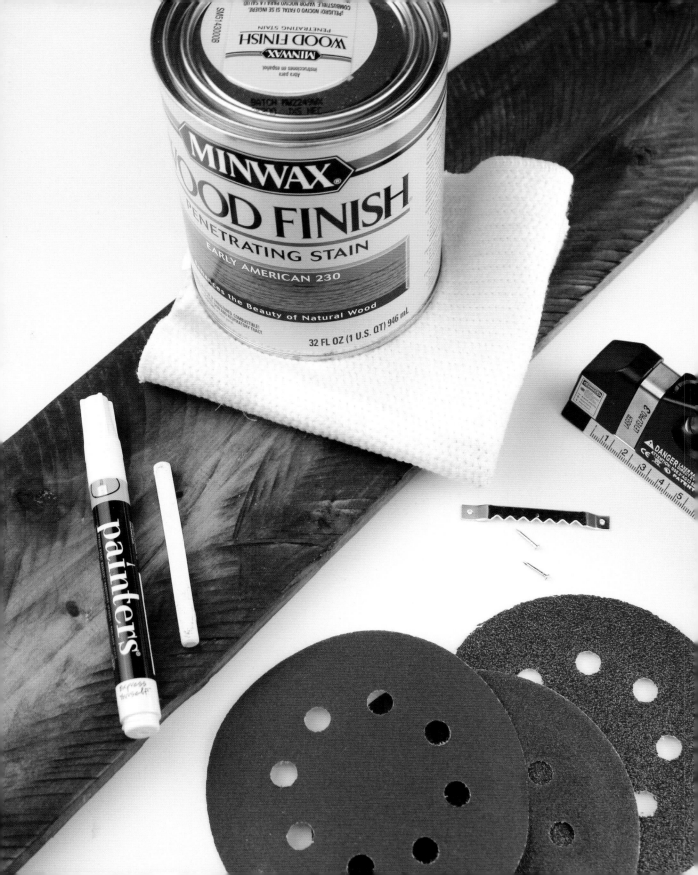

A STARTER TOOLBOX

Now that you have practiced your lettering in three styles that will take you far, it's time to introduce you to some of the most versatile tools and materials for creating hand-lettered signs. Not all of these materials are used in every project, but they will help you build a great toolbox for your designs. Keep in mind that there are many brands and options out there, as close as your local hardware and craft stores, so choose what works best for you and your budget.

WOOD FOR SIGN BASE

- Whitewood common boards in 1" thickness
- Underlayment plywood boards in ¼" thickness
- Pallet wood boards

WOOD FOR BUILDING FRAMES

- 1" x 2" furring strips (usually sold in 8' lengths), for slightly rounded edges
- 2" x 2" furring strips, for squared edges
- ¾" x ¾" pine molding
- $^{11}/_{16}$" x $^{11}/_{16}$" pine molding
- Wood frames from thrift stores

WOOD STAIN & CLOTH FOR APPLICATION

- My favorites: Minwax Early American and Provincial (mid-brown), Dark Walnut and Jacobean (dark wood), and Classic Gray
- Microfiber cloths (or white cotton T-shirts)

Look for interesting detail and texture.

PRIMER, PAINTS, CLEAR COATS & BRUSHES

- Primer (This undercoat for a white painted sign keeps wood knots from seeping through. I like Kilz brand.)
- Flat white latex paint
- Black chalkboard paint
- Polycrylic satin or matte clear coat
- Paint pens
- Acrylic paint or latex paint samples in multiple colors, for adding details and embellishments to signs
- Synthetic-bristle paintbrushes in various sizes (For some projects, small paint rollers may also be efficient.)

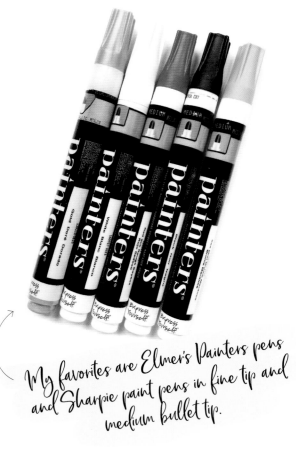

My favorites are Elmer's Painters pens and Sharpie paint pens in fine tip and medium bullet tip.

POWER TOOLS

- Power sander: orbital sander or mouse sander with various sanding discs
- Miter saw and circular saw (Or find a hardware store near you that will cut wood to your specifications. Usually, a few cuts are free and then a nominal fee may apply for additional cuts.)

HAND TOOLS

- Sandpaper in coarse (80), medium (120), and fine (220) grits
- Laser level
- Ruler
- Tape measure
- Scissors
- Hot glue gun
- Bar clamps or smaller hand clamps
- Brad nailer and finishing brad nails
- Screwdriver
- Hammer

OTHER HELPFUL SUPPLIES

- Tack cloth
- Heavy-duty adhesive or wood glue (like Liquid Nails or Titebond)
- Paper and marker
- Chalk
- Painter's tape
- Twine
- D-rings, with accompanying screws
- Picture wire
- Sawtooth hangers, with accompanying nails

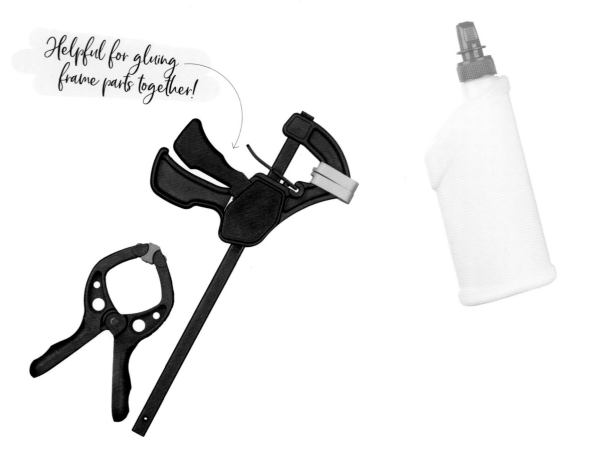

Helpful for gluing frame parts together!

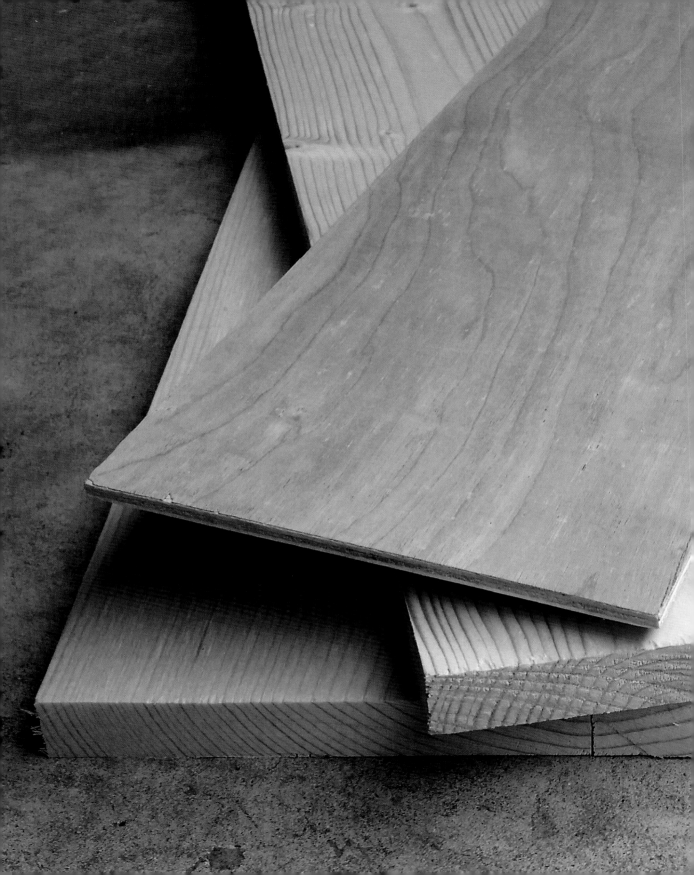

SOURCING & PREPPING WOOD

Giving your hand-lettered sign a great start begins with the wood. Where should you go and what should you look for to make a selection? What do you need to do to get your wood material ready to hang sturdily in your home (or a friend's) and looking gorgeous for a very long time? Here are the essentials I have learned.

SMART WOOD CHOICES

DISCOUNT WOOD: My first wood-shopping stop is always the discount pile of my local home improvement store. Ask an associate where this selection is located. Look for any length of wood with a thickness of 1 inch or less. This size is ideal because it is sturdy but lightweight and can sit on a mantel or hang on a wall. Avoid warped wood in favor of pieces that are straight and flat.

- **Buying tip:** Lay a piece of wood on the store floor. Make sure that it will lie flat and doesn't curl away from the floor.

WHITEWOOD COMMON BOARDS: I buy Premium Kiln-Dried Whitewood Common Board, because it is 1 inch thick with square edges and comes in 4- to 12-inch widths. It is usually the least expensive type of plank at a hardware store, has a light color, and takes stain well. Select boards are also good options. They are a step up from common boards in both quality and cost.

UNDERLAYMENT ¼-INCH HARDWOOD PLYWOOD: I love using this wood because it is so lightweight and has a smooth surface for lettering. Underlayment hardwood is sold in 4-foot x 8-foot panels; ask for cuts at the store. This wood will splinter along the edge when it is cut, so plan to sand these edges at home. This wood can also take a stain, but the splintered edges can pose a problem. I recommend covering the splintered edges by creating a frame for your sign.

Many home improvement stores will cut large pieces of wood in store for free. If you would like your wood to be cut in store for you, call ahead to make sure the saw is operational. The last thing you want is to arrive to find the saw is out of order.

A SMOOTH START

Before I apply stain or paint, I always sand my wood. This step prepares the surface for lettering, allowing me to write without the paint pen skipping or getting snagged on the wood. A rough piece of wood will shred the tips of paint pens, so prepping the wood is key. Power sanders make it easy work. I own the Black & Decker Random Orbit Sander, which is 5 inches, but there are lots of choices. A smart bet: look for a model with a dust collector. No matter what sander you use, follow this process.

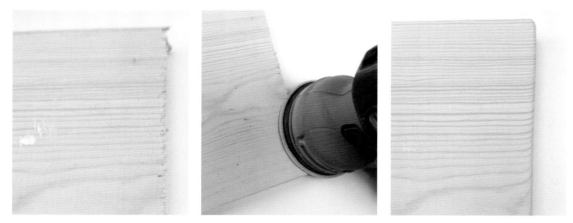

1. **START LOW:** Begin sanding with a lower (coarser) grit sanding disc or sandpaper and progress to a higher (finer) grit for a smooth finish. I like to start with 80-grit coarse, then sand with 120-grit medium, and finish with 220-grit fine. The exact process depends on the condition of the wood. Banged-up pallet wood should go through the whole progression of coarse to medium to fine, but underlayment plywood usually just needs a light sanding with fine grit.

2. **SAND SLOWLY:** If you try to cover the board quickly, you will get little spiral scratches in the wood from the circular sander. You might not see these appear until you stain. Sand with the grain of the wood and move your way across the piece slowly.

3. **CLEAR THE SURFACE:** Before you make a move to stain, paint, or letter your newly sanded wood, don't forget to remove the dust. A great team for the job: a damp microfiber cloth followed by a tack cloth, a slightly sticky cloth that does a great job catching any last dust on your wood. You can find tack cloth in hardware stores. Cut a small piece to use rather than the whole cloth.

Sanding complete? Grab a lonely sock that's missing its mate. Rub the sock over the wood surface. If the sock snags on the wood you need to keep sanding.

Before you use a tack cloth or microfiber cloth, grab a pair of scissors and cut each large cloth in halves or fourths. You don't need to use such a large piece for cleaning boards and staining. This will help stretch your supplies and allow you to create so many more signs!

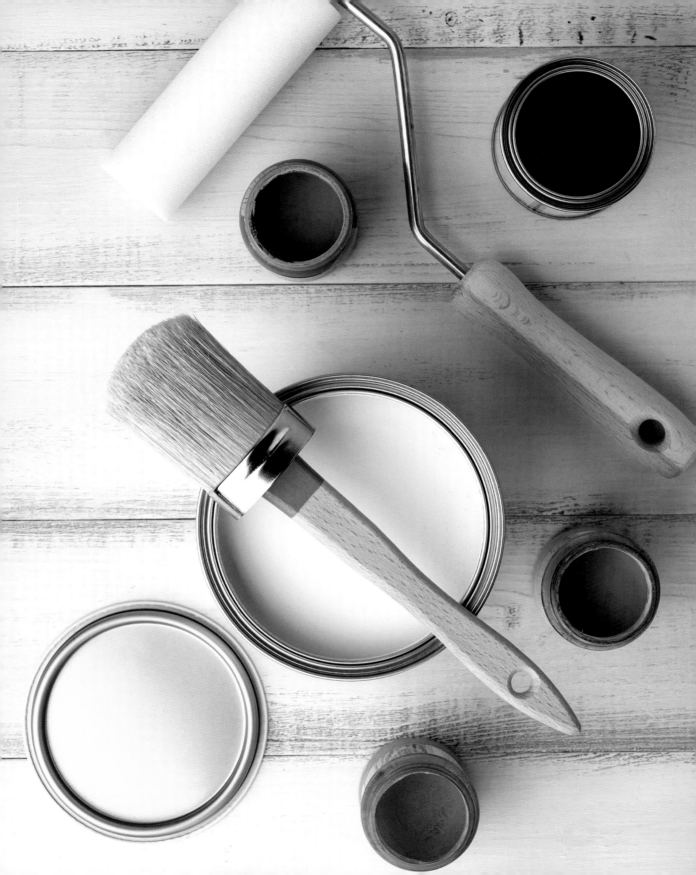

PAINT & STAIN POINTERS

Once your sign's surface is prepped at a basic level, there is one more step before unleashing the lettering. For each sign project, you will choose how to finish the background surface—anything from a warm stain to a gentle whitewash, from bright white paint to black chalkboard paint. Whether you use what the project calls for or choose something different to make the sign your own, follow these tips for beautiful results.

PAINTING

Interior latex with a flat finish is usually the best paint choice for hand-lettered signs. It dries to a hard, durable surface that takes paint pens really well. One case in which you may want to make an exception: designing a sign that will get touched often, such as the Laundry Lost & Found sign (page 147). For that situation, a satin finish that is very wipeable makes sense.

Whatever paint you choose, consider whether you need to start with a primer. If there are knots in your wood, use a primer to seal those—especially if you are painting the sign's surface white. The primer keeps the knots from seeping a yellowish color through the white paint over time. After the primer has dried (per directions on the paint can), you will need to apply only one or two layers of latex paint. When the paint is dry, your surface is ready—no need for a clear top coat or sealant.

WHITEWASHING

I love the beautiful farmhouse look of whitewashed wood. It allows for the gorgeous wood grain to come though the white paint. To create a simple DIY whitewash, mix two parts white paint with one part water in a clean container.

Use a paintbrush to apply the wash onto your board. Paint in the same direction as the wood grain, just like you would apply stain. Experiment with more or fewer coats to get the look you love.

Painting more than one coat? Wrap your brush or roller in a plastic grocery bag to keep it from drying out in between coats.

STAINING

WOOD CONDITIONER (OPTIONAL): Using wood conditioner before staining can help you achieve an even surface. I usually skip this step when I am treating pallet wood, because the uneven stain highlights the rustic character of the dents and holes already in the wood. But if I am staining new wood, I use wood conditioner first.

Choose either water-based or oil-based conditioner, depending on which stain you will use (i.e., water-based stain will need water-based conditioner). After the wood has been sanded and dusted, in a well-ventilated area, brush on one coat of the conditioner. Follow the label instructions, which generally advise letting it sit for 1 to 5 minutes, removing excess conditioner with a cloth, and lightly hand sanding the surface 15 to 30 minutes later.

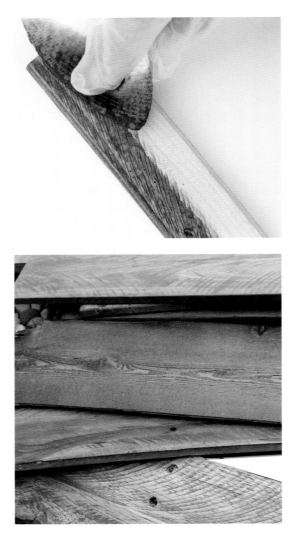

STAIN: It might be too dramatic to say that staining wood incites fear in many people, but this step definitely seems to intimidate. Don't let this happen to you! Applying wood stain is easy once you get the process down. I recommend wearing gloves to contain the mess and using a microfiber cloth to rub the stain into the wood. You get more control with a cloth than a paintbrush, which helps the process. The techniques to use:

- Follow the wood grain with long, broad strokes.
- Don't allow puddles of stain to stay on the wood board.
- Spread out the color so that you have an even application.

The stain enhances the wood grain, so expect to see more variation in the wood. You can always add more coats of stain to darken the color. My favorite wood stain colors for home signs are Minwax Early American and Provincial (mid-browns), Dark Walnut and Jacobean (dark browns), and Classic Gray.

CLEAR COAT: Polycrylic is a water-based clear protective top coat. I only use it over a stained wood sign so that the sign can be easily dusted. Polycrylic comes in a variety of finishes: gloss, semigloss, satin, and matte. Choose matte if you like the look of naked wood, or choose gloss if you like a little shine.

With a clean synthetic-bristle brush, apply polycrylic to your wood in the same direction as the wood grain. Work in thin, even coats. Once the wood is completely covered in a coat, hold your brush at a 45-degree angle and lightly move the brush from one end of the wood piece to the other end. Repeat until you have smooth strokes all the way down the wood. This little step gets rid of sneaky brushstrokes, smooths out any puddles, and breaks up bubbles that might have formed.

If you want to apply additional coats of polycrylic, check that the first coat has dried and then lightly hand sand using 220 fine-grit sandpaper. Make sure all of the sanding dust is off of the wood before applying another coat.

Polycrylic clear coat has a milky look when you apply it on the wood. Don't worry: it will dry completely clear and much less shiny, depending on the finish you have chosen.

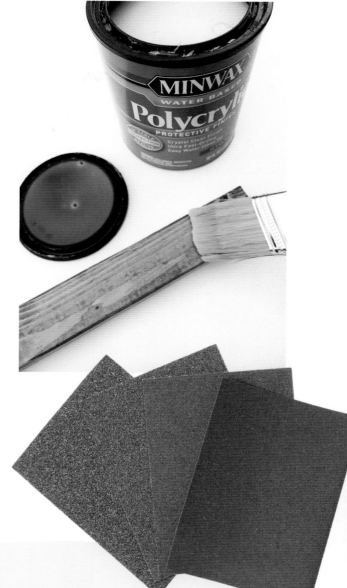

Distressing

Do you want to add distressing to your sign? To distress a painted or stained wood piece, hand sand the edges and maybe even the face of the wood with 120 medium-grit sandpaper. Then lightly go over the distressed area with 220 fine-grit sandpaper to get a super smooth finish. Only matte paint, chalk paint, or flat paint should be distressed. If you try to distress paint with a gloss (such as eggshell paint or high-gloss latex paint), the paint will peel rather than sand off.

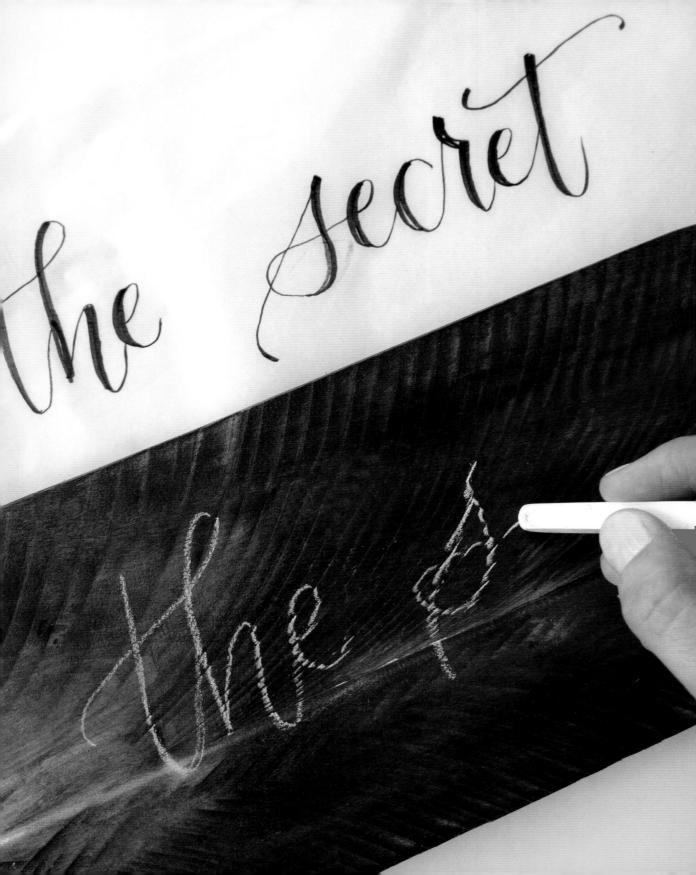

LETTERING TECHNIQUES & TOOLS

You've practiced the lettering fonts. When it's time to take them to your prepped wood sign, you can feel the creative energy really flowing. Even still, knowing certain proven techniques and choosing the right lettering tools can ensure you get the results you want. Take these tips from what I've learned in the process of making hundreds of my own hand-lettered signs.

TRANSFERRING WORDS TO A SIGN

There are two methods I use to take my words from practice paper to wood sign. Both require just a few simple tools to ease the process.

OPTION 1: Use chalk, a laser level, and a practice sheet.

1. On a piece of scrap paper to scale, write out your lettering word or phrase in marker in the exact size that you would like it to appear on your sign.

2. Adjust the paper so that it is just above your wood and easy to view.

3. Using a laser level to establish a baseline and your practice paper as a guide, write on the wood sign with a contrasting color of chalk.

4. Letter over the chalk guidelines with the paint pen, making adjustments as needed.

5. When the paint is completely dry, use a damp microfiber cloth to wipe away the chalk marks.

I love this method because my lettering stays lined up and level, but I can freely form my letters without the wiggle lines that sometimes sneak in when trying to trace too closely!

I buy chalk sticks in black (for light paint or stain signs) and white (for dark paint or stain signs) and sharpen them with a small hand sharpener. The laser level is from a home improvement store.

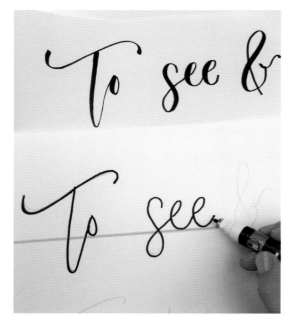

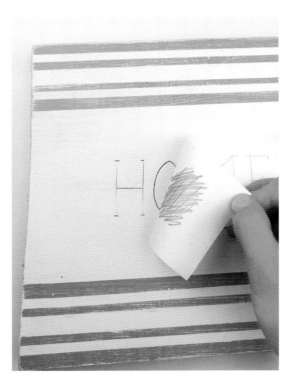

OPTION 2: Use the pencil transfer technique.

1. Design your lettering on a piece of paper.

2. Flip the paper over and color the back with pencil or chalk.

3. Turn your design back over and place it on the wood.

4. Using a pencil, firmly trace your printed design. This step transfers the chalk or graphite onto the wood!

5. Go over the design with a paint pen.

6. After the paint is completely dry, erase any visible pencil or chalk.

This option is particularly helpful when you're working with intricate designs.

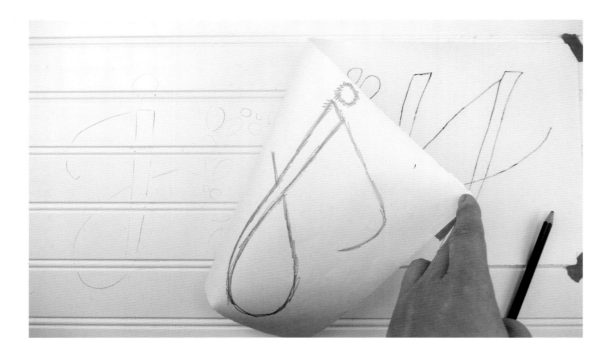

CHOOSING & USING PAINT PENS

There are tons of paint pen options available. They are amazingly efficient and provide much more control when lettering compared to using a paintbrush. So which do you choose? It can help to ask lettering friends which paint pens they find easy to use. (My personal favorites are Elmer's Painters pens and Sharpie paint pens.) All paint pens have their quirks, though, and can be frustrating without the right tips for using them. These are the lessons I have learned through hundreds of trials and errors—and splattered paint!

MATCH THE TIP TO THE NEED: Medium-tip paint pens are my go-to. The bullet tip is easy to work with, and the size is good for both details and lettering. They are sold individually or in packs. I stock up on white because I go through those quickly when writing on dark stain (those signs often need four or five coats of paint).

Fine-tip paint pens are good to have on hand for adding details and florals. Sometimes I will outline a leaf with a medium marker but then add in the veining of the leaf with a fine tip. Fine tips are also good for writing on small wood slices!

To get beautiful opaque letters, you need to paint multiple coats of white paint. I recommend stocking up on white paint pens!

PREP YOUR PEN: Before you can begin lettering, you need to get your paint pen ready. Start by making sure the cap is tightly in place and shaking your pen. You should hear a rattle sound as the paint mixes in the barrel of the pen. Many paint pens have spring-loaded tips, which means that you need to press the tip firmly onto a piece of paper to start the flow of paint. Depress the tip of the pen onto a clean sheet of paper until the paint begins to flow. I "bounce" the pen (depress, let up pressure, depress, let up pressure) to get the paint started. While you are working on a sign, you may need to revisit these steps of shaking the pen and depressing the tip on paper if you notice the paint is not flowing well. Always do this on a clean sheet of paper rather than your sign to protect your project from paint blobs that sometimes escape.

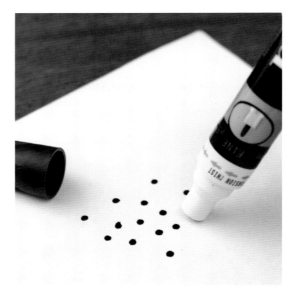

WATCH FOR AN EMPTY CHAMBER: You will know that your pen is out of paint when you start to see diluted color or watery residue come out of the pen rather than opaque paint. Others signs you're running on empty: you shake the pen and it feels light in weight and has a loud, empty rattle.

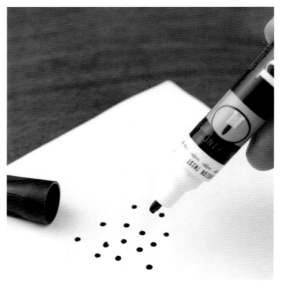

PAY ATTENTION TO DRY TIMES: There is a difference between paint that is "dry" and paint that is "set." Your paint might feel dry to the touch, but the first coat could start to peel up or stick to your hand when you try to add another coat. If this happens, stop and wait for more dry time for the paint to set. My rule of thumb is to wait 10 minutes between coats. It may seem excessive, but you won't risk "globby" letters. Test out your paint to find the right amount of drying time for you. Know that the temperature of your room and the humidity levels can impact dry times.

ACCENTING WITH ACRYLIC PAINT

You can use paint pens for pretty line work, but you will run through them really quickly—trust me. When I want to design florals or other details, I use acrylic paint. It is much more cost-effective to add details with paint and a brush than with paint pens. I look for paint with a matte finish and stock up on a very basic collection of colors—white, black, brown, red, yellow, and blue. With those selections, I can mix whatever colors I need.

If you are painting with acrylics over a colored surface or dark wood stain, keep the paints at full strength (do not add water). When painting on a white sign, I love to add a little water to the paint to get a watercolor effect. The great thing about watered-down acrylic is that, unlike watercolor, the paint does not dry lighter. So how you paint it is how it will dry.

FRAMING & HANGING HINTS

Not every sign needs a frame. Raw edges can be beautiful and give your sign a rustic look. But if you're looking for a finishing touch, it's simple to keep the DIY rolling and design your own custom frame. Then just add the right hanging hardware for the project, and you're all set to display (or gift) your new creation!

FRAMING OPTIONS

Sometimes, thrift-store finds are the perfect frame for a project. When you opt to make your own frame, you have a few paths to choose.

- **FURRING STRIPS:** These wood pieces are slightly rounded at the edges and come in 1 inch x 2 inch and 2 inch x 2 inch. Furring strips stain well and are easy to work with when framing a sign.
- **PINE MOLDING:** You can also create frames from molding pieces. These usually have more squared edges and come in a variety of sizes.

When I frame my signs, I create two types: mitered corners (45-degree angled cuts) and stacked corners. The process for attaching the frame to the sign is the same for both types.

HOW TO FRAME ¼-INCH UNDERLAYMENT SIGNS

1. Measure so that your frame will stack on top of the underlayment and form a border around it. Use the age-old tip: measure twice, cut once.

2. Stain the frame pieces and allow them to dry before you assemble.

3. Apply adhesive (Liquid Nails or wood glue) to the edge area of the sign where the frame will overlap. Keep your glue toward the outside edge, so that when you add the pressure of the clamps, the glue is more likely to squeeze outside rather than toward the lettering. Secure each frame piece.

4. Clamp the frame to the sign using spring clamps. Clean up any glue that might squeeze out with a damp rag.

Check out the diagram on the next page to help visualize the process.

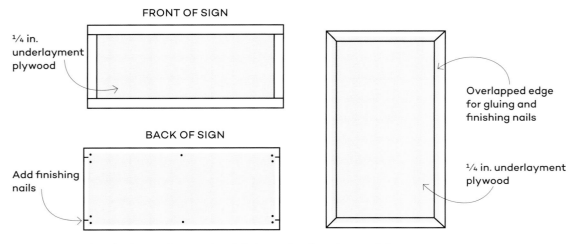

FRONT OF SIGN

¼ in. underlayment plywood

BACK OF SIGN

Add finishing nails

Overlapped edge for gluing and finishing nails

¼ in. underlayment plywood

Cut the frame pieces to be slightly smaller than the wood sign you are framing. Glue and clamp the frame pieces to the plywood. Add finishing nails into the back of the plywood connecting it to the frame pieces.

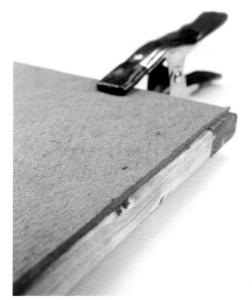

5. With the clamps still in place, flip the sign over. Use a brad nailer to shoot ¾-inch finishing nails through the back of the sign into the frame—at least three for each frame piece.

6. Remove the clamps and allow the adhesive to dry.

The combination of the glue, nails, and overlapped edge creates a strong, sturdy frame! Whether you choose mitered corners (45-degree angled cuts) or stacked corners, the process is the same.

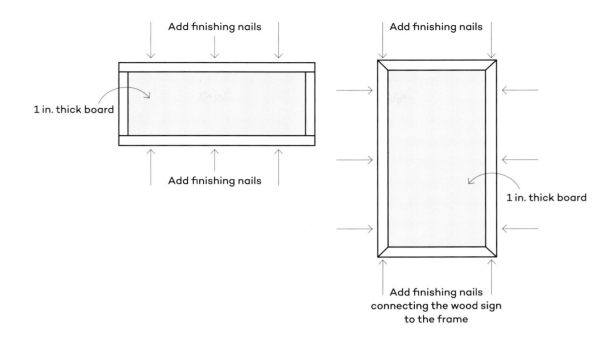

Add finishing nails

1 in. thick board

Add finishing nails

Add finishing nails

1 in. thick board

Add finishing nails
connecting the wood sign
to the frame

HOW TO FRAME 1-INCH BOARD SIGNS

1. When you work with 1-inch-thick pallet wood or 1-inch-thick common board, you will not want to make the frame overlap the sign—that could look bulky. Instead, create the frame to fit snug right around the edges of your sign. Remember: measure twice, cut once.

2. Stain the frame pieces and allow to dry before you assemble.

3. Apply adhesive (Liquid Nails or wood glue) to the edges of your wood board and secure each frame piece to the sides of the board.

4. Clamp the frame in place using long bar clamps. Clean up any glue that might squeeze out with a damp rag.

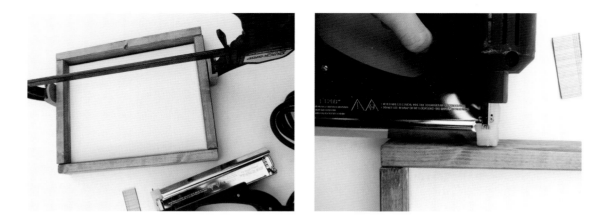

5. With the clamps still in place, use a brad nailer to secure the frame with 1¼-inch finishing nails. Nail through the outside of the frame into the side of the sign, two to three nails for each length of frame.

6. Remove the clamps and allow the adhesive to dry.

HANGING HARDWARE

SAWTOOTH HANGERS: Adding large sawtooth hangers is the easiest and most versatile way to get your signs ready for display. These hangers are sold at home improvement stores and either come with little nails or have a built-in nail system. When you're ready to add a hanger to the back of an unframed sign, use a tape measure to mark the center of the sign. Then attach the sawtooth hanger to the upper back of the sign. When working with a framed sign, place the hanger into the back middle of the frame. With a hammer, simply tap the two small nails into the preformed holes on both sides of the sawtooth.

D-RING HANGERS: For any wood sign over 4 feet square, I recommend using two large D-ring hangers. Mark where you will place them on the back of your sign, equidistant from each side of the sign. Then use a laser level to make sure they are in line with each other. The ring is positioned facing up, and the two screw holes face down. Use a power drill with a screwdriver attachment to drill the screws into the panel. You can then use picture wire to string a line between the two hooks, or you can leave the hooks as is for hanging on two drywall screws.

⟩ 3 ⟨

COMING HOME
TO CALM

there is no place like

home

NO PLACE LIKE HOME

I don't know how many times you have moved into a new home. Including my college and graduate school spans, there was a period of time when I moved into a new apartment or home every year for ten years. Pretty exhausting! Even during this time, though, I remember that there was always a moment, often a few weeks after moving into a new place, when I would refer to my space as "home" and smile. There is something so remarkable about the feeling of home. That's why this sign is a front entryway must-have for me.

SUPPLIES

- ¾" birch plywood board, 24" x 48"
- Tack cloth
- Microfiber cloth, for stain application
- Minwax Dark Walnut stain (or stain of your choice)
- Paper and marker, for practice lettering
- Laser level
- White chalk
- White medium-tip acrylic paint pen
- Clean microfiber cloth
- Tape measure
- D-rings, with accompanying screws
- Screwdriver
- Picture wire

DIRECTIONS

1. **PREP THE WOOD:** Remove dust from the board with the tack cloth. Using the microfiber cloth, apply the stain to the front of the wood board, following the wood grain. Allow the stain to dry, according to the directions.

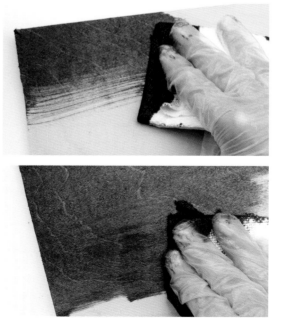

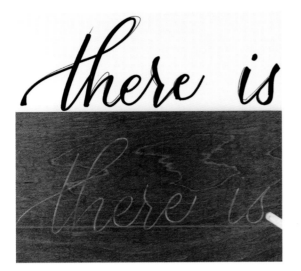

2. **BEGIN THE LETTERING:** On scrap paper the same dimensions as your board, write the sign's phrase in Faux Calligraphy. Practice until you are satisfied with the style and spacing.

3. Line up your practice lettering sheet just above the front side of your wood board. Using the laser level to establish a baseline for your text, chalk the quote onto the wood.

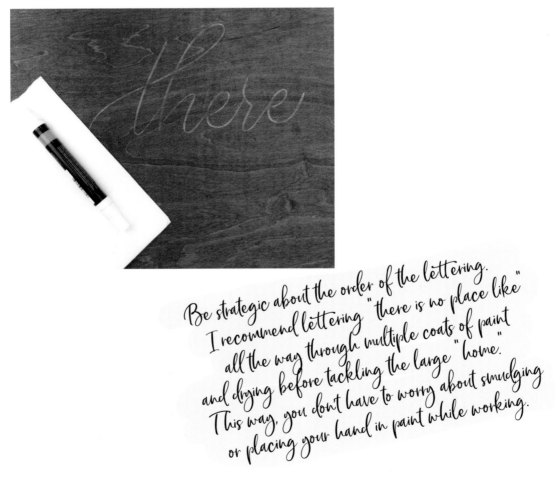

Be strategic about the order of the lettering. I recommend lettering "there is no place like" all the way through multiple coats of paint and drying before tackling the large "home." This way, you don't have to worry about smudging or placing your hand in paint while working.

4. Working slowly, write over your chalk guides with the paint pen, smoothing out any wobbly letters. Allow the paint to dry completely to the touch, and then erase the chalk guidelines with a damp microfiber cloth.

5. "Double up" your downstrokes (see the technique on page 7). Allow the paint to dry and then add another coat of paint to your letters. Continue adding a total of three or four coats of paint, allowing each coat to dry before starting the next, until you have an opaque covering.

Lettering at this large of a scale can be tricky. Work slowly and plan to trace multiple layers of paint over the letters, especially for the word "home".

6. **DESIGN THE EMBELLISHMENTS:** Follow the floral progression shown here as inspiration. Start by creating a large cluster of main flowers. These anchor the design. Next, fill in large leaves and finish with smaller flowers and berries.

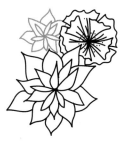
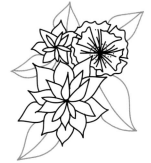
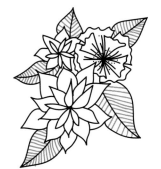

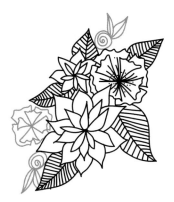
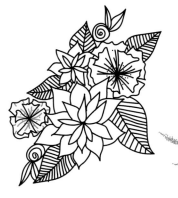
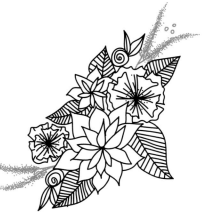

7. **ADD HANGING HARDWARE:** When the paint is dry, flip the sign over. Measure and mark 6 inches from the top of each corner of the sign. Attach the D-ring hangers with the screws provided. String the picture wire between the two hangers and twist to secure in place.

Take care when twisting the picture wire—the frayed ends can be sharp!

MIX IT UP

A. Mix lettering style—try Block Print with Faux Calligraphy.

B. Use Faux Calligraphy (with a few alternate letter styles for *r*, *o*, and *k*), then play up *home* in a Block Print variation.

C. Rotate the sign and try Cafe Print with greenery accents.

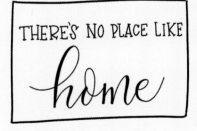

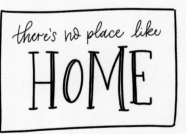

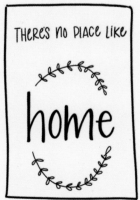

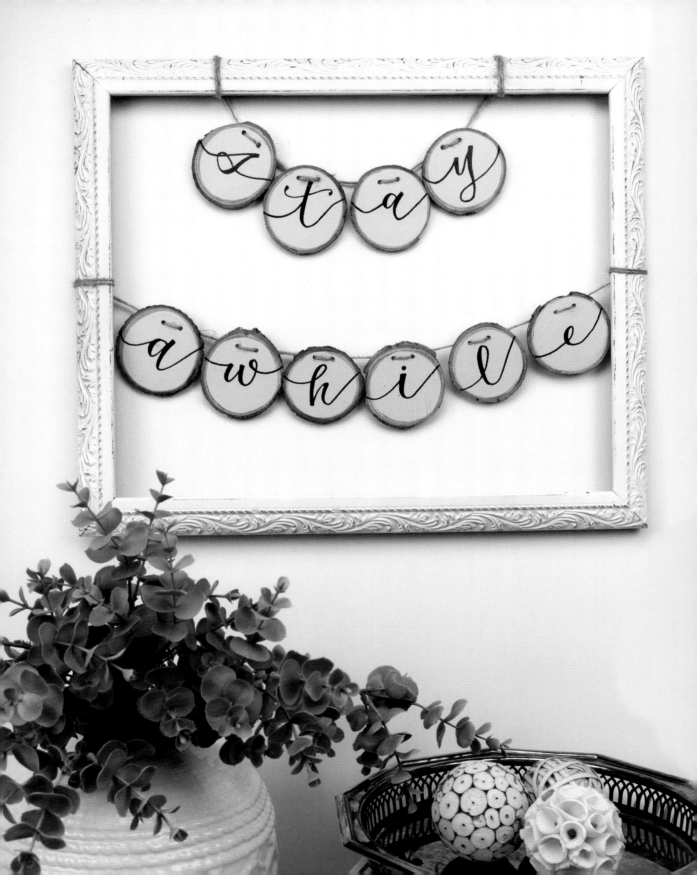

STAY AWHILE

One of my favorite places to hang a hand-lettered sign is near the entrance of my home. It's a conversation starter and a personal invitation to guests! The floating letters on twine are eye-catching and welcoming but also versatile. I chose to glue the wood slices into a frame I bought from a thrift store, but you can adapt this project to make a beautiful banner to hang from your mantel.

SUPPLIES

- 10 wood slices*
- 2 1" angled paintbrushes
- Primer
- Fine-grit sandpaper
- Tack cloth
- Light-colored indoor latex paint (I used Behr Dolphin Fin)
- Cordless power drill with ⁹⁄₆₄ drill bit
- Black or dark-colored chalk
- Black fine-tip acrylic paint pen
- Microfiber cloth
- 4' length twine
- Picture frame without glass, painted white (Mine was a thrift store find!)
- Hot glue gun
- Masking tape
- Scissors
- Tape measure
- Small (3") sawtooth hanger, with accompanying nails (optional)
- Hammer (optional)

* Sold at craft stores or online

DIRECTIONS

1. **PREP THE WOOD:** Lay out all 10 wood slices. Paint each one with a layer of primer. Allow the primer coat to dry, according to the directions.

2. Lightly sand the primed slices by hand to smooth out any small bubbles or bumps. Remove any dust from the slices with the tack cloth.

3. Paint each slice with a layer of light-colored latex paint. Allow the paint to dry, according to the directions.

4. **CREATE THE HANGING HOLES:** Drill two holes through the top of each slice, about ½ inch down from the top and ½ inch apart from each other. This two-hole technique will keep the letter side of the slice facing out. (I drill on a cardboard box that I grab out of my recycling. It's an easy way to protect the work surface underneath.)

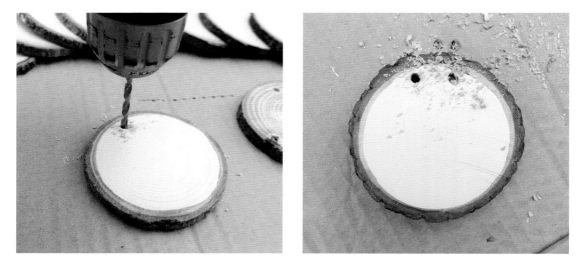

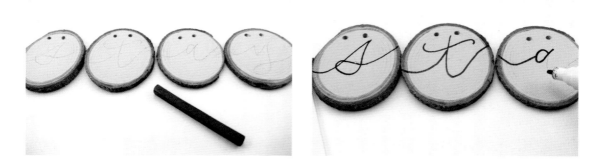

5. **BEGIN THE LETTERING:** Write one letter on each wood slice with the black chalk, spelling out "Stay Awhile" in Faux Calligraphy.

6. Working slowly, write over your chalk guides with the paint pen, smoothing out any wobbly letters. Allow the paint to dry completely to the touch, and then erase the chalk guidelines with a damp microfiber cloth.

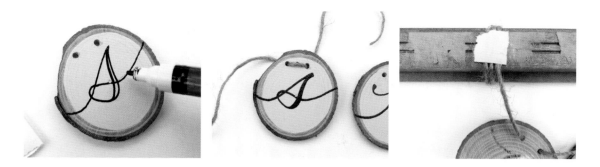

7. "Double up" your downstrokes (see the technique on page 7). Allow the paint to dry before moving on to the next step.

8. **ADD TWINE:** String the wood slices on the twine. I chose to string "Stay" on one 2-foot length of twine and "Awhile" on another 2-foot length of twine.

9. Wrap the ends of the twine around the frame twice and hot glue to the back. Place a piece of masking tape on top of the hot glue to press until the glue dries. (This trick allows you to put pressure on the string as the glue dries while protecting your finger from getting burned.) When the glue is dry, remove the tape and trim any excess twine.

10. **IF NEEDED, ADD HANGING HARDWARE:** Many frames will already have hanging hardware. However, if yours does not, it's easy to add a small sawtooth hanger. Flip the frame to the back, then use a tape measure to find and mark the center of the top of the frame. Center the sawtooth hanger horizontally. With the hammer, carefully tap the two small nails into the board.

MIX IT UP

A. Skip the frame and thread the wood slices onto the twine in a single line. What a perfect banner to hang from your mantel!

B. Create a two-tiered banner to hang on a wall or mantel. Add an additional wood slice for a floral embellishment.

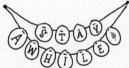

C. Switch to Cafe Print and try a whimsical diagonal arrangement.

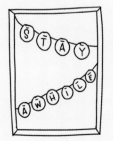

To see & be seen.
That is the truest
nature of love.

welcome
home

NATURE OF LOVE

How would you define love? It's a word we use often but sometimes have a hard time defining. If I were put on the spot to give my definition, I think I would either go on and on, giving examples, or find myself without words to accurately capture its meaning. The quote featured on this sign resonates with me in the simplicity of the statement but also the complexity of the meaning. It inspires me to think about the nature of love each time I read it.

SUPPLIES

- Orbital sander, with medium- and fine-grit sanding discs
- 2 furring strips, 49"
- 2 furring strips, 21½"
- Underlayment plywood, 24" x 48"
- Tack cloth
- Paintbrushes or small roller
- Primer
- White indoor latex paint, flat
- Microfiber cloth, for stain application
- Minwax Early American stain (or stain of your choice)
- Paper and marker, for practice lettering
- Laser level
- Black chalk
- Black fine-tip acrylic paint pen
- Clean microfiber cloth
- Wood glue
- Spring clamps
- Brad nailer and ⅝" finishing brad nails
- Tape measure
- Large (5") sawtooth hanger, with accompanying nails
- Hammer

DIRECTIONS

1. **PREP THE WOOD:** Sand the furring strips with medium-grit and then fine-grit sandpaper. (See technique tips on page 58.) Clean the newly sanded strips and the piece of underlayment plywood with the tack cloth. Set the furring strips to the side.

2. Using a small roller or brush, paint the underlayment board with a layer of primer. This step will keep the wood grain or knots from bleeding through the white paint. Allow the primer coat to dry, according to the directions.

3. Using a small roller or brush, paint the underlayment board with a layer of white latex paint. Allow the paint to dry, according to the directions.

4. Using the microfiber cloth, apply the stain to the front, sides, and ends of the furring strips, following the wood grain. Allow the stain to dry, according to the directions.

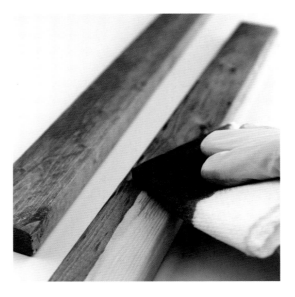

5. **BEGIN THE LETTERING:** On scrap paper the same length as your underlayment board, write the sign's phrase in Faux Calligraphy. Practice until you are satisfied with the style and spacing. Remember to leave space for the two leaf details on your practice sheet.

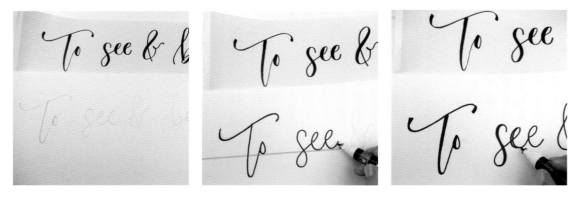

6. Line up your practice lettering sheet just above the front side of your board. Using the laser level to establish a baseline for your text, chalk the quote onto the wood.

7. Working slowly, write over your chalk guides with the paint pen, smoothing out any wobbly letters. Allow the paint to dry completely to the touch, and then erase the chalk guidelines with a damp microfiber cloth.

8. "Double up" your downstrokes (see the technique on page 7). Allow the paint to dry and then add just one more coat of paint to your letters. Black paint pens don't need as many coats of paint as the white ones.

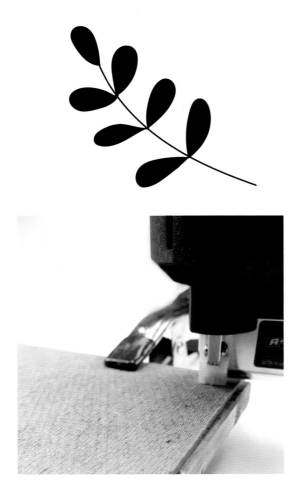

9. **DESIGN THE EMBELLISHMENTS:** Follow the design at left as inspiration. Begin with a stem, then, starting with the single leaf at the top, add leaves of increasing size. Finally, fill in the leaves with the paint pen.

10. **FRAME THE SIGN:** Apply wood glue to the furring strips. Attach the furring strips along the front edge of the underlayment sign board. Clamp in place. Once all four pieces are set, turn the sign over.

11. Use the brad nailer to add two finishing nails on each side of the sign, connecting the underlayment board to the furring strips. Clean up any glue that might squeeze out with a damp rag.

12. **ADD HANGING HARDWARE:** After the wood glue has completely dried, remove the clamps and flip the sign over. Use a tape measure to find and mark the top center of your underlayment board. Center the sawtooth hanger horizontally and about ½ inch down from the top, so that it is lined up in the middle of your furring strip on the front. With the hammer, carefully tap the two small nails into the board.

MIX IT UP

A. Try a mix of uppercase and lowercase Cafe Print. Bump the lettering to the left to leave room for a leaf detail.

B. Center the text with a mix of Block Print and Faux Calligraphy.

C. Highlight the first part of the phrase in large Faux Calligraphy, paired with a smaller Cafe Print for the rest.

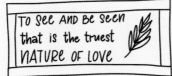

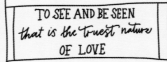

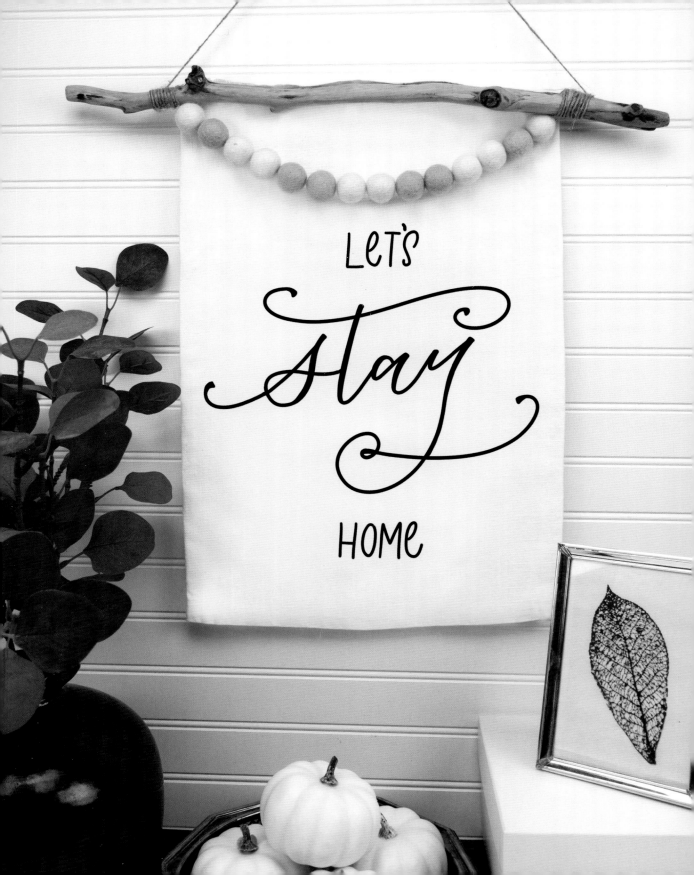

LET'S STAY HOME

If you could describe your home using one word, what would it be? Mine is cozy. I want my home to be a place of belonging and comfort, a place to gather and just be together, a place where you want to stay. This sign is that reminder to simply linger and enjoy the company of loved ones. It can be customized with bright-colored felt pom-pom balls, dramatic black and white poms, or calming neutrals like the cream and white poms I chose. Have fun finding the color scheme that fits your home and your family best.

SUPPLIES

- Raw stick*
- Orbital sander, with coarse-, medium-, and fine-grit sanding discs
- Tack cloth
- Paintbrush
- Polycrylic clear top coat, matte
- Paper and marker, for practice lettering
- Pencil and white eraser
- Primed canvas cloth, 18" x 24"
- Laser level
- Ruler or triangle, for print lettering
- Black fine-tip acrylic paint pen
- Hot glue gun
- Sewing needle and thread
- 14 felt pom-pom balls, 1" size
- 4' length twine

Can be purchased at a craft store

DIRECTIONS

1. **PREP THE WOOD:** Sand the stick in a progression with coarse-, medium-, and fine-grit sandpaper. (See technique tips on page 58.) Remove excess dust from the stick with a tack cloth.

2. Using a paintbrush, apply a thin layer of polycrylic top coat to the stick. Allow the top coat to dry, according to the directions.

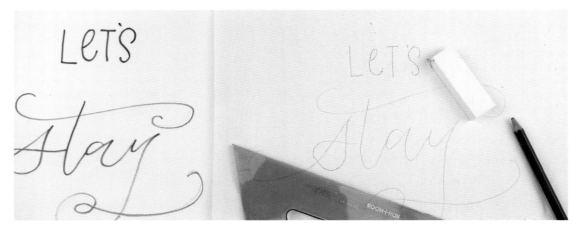

3. **BEGIN THE LETTERING:** Plan out the lettering on a piece of paper the same size as the canvas cloth. Using a pencil, transfer the lettering onto the canvas using either the direct transfer method or the laser level transfer method (see lettering transfer techniques on pages 65 and 66). Use the ruler or triangle to establish your baseline for the Cafe Print.

Primed canvas is a great surface for erasing and rewriting. Use your white eraser to edit out mistakes and get the layout of letters that you want.

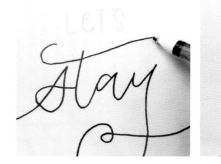

4. Trace over your pencil guidelines with the black paint pen. Allow the paint to dry before adding another coat of paint.

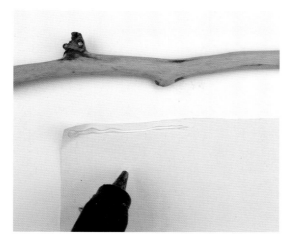

5. **ASSEMBLE THE SIGN:** Center the canvas horizontally on the stick and hot glue it to the back of the stick.

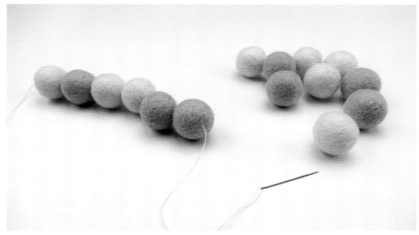

6. **CREATE THE POM-POM BANNER:** Thread the needle through the pom-pom balls, creating a desired pattern.

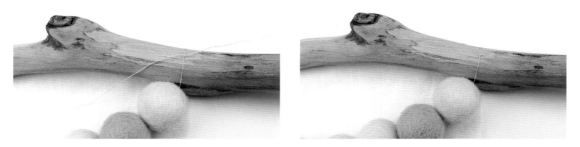

7. Cut the thread away from the needle and tie the thread into a knot around both ends of the stick.

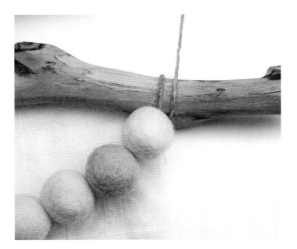

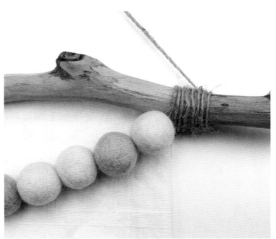

8. Wrap the twine around the left edge of the stick 10 times, making sure to cover the thread from the pom-pom banner. Wrap the other end of the twine around the right edge of the stick 10 times. Glue the twine in place and trim away any excess. Now you're ready to hang this lightweight sign from a small nail or thumbtack in the wall.

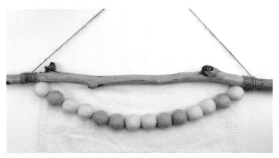

MIX IT UP

A. Create the sign with a casual look, using Cafe Print.

B. For more subdued calligraphy, try monoline Faux Calligraphy with straight lines.

C. Have fun with Faux Calligraphy, extending the lines off the canvas.

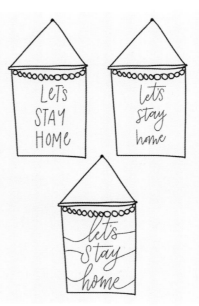

4

KITCHEN & DINING WARMTH

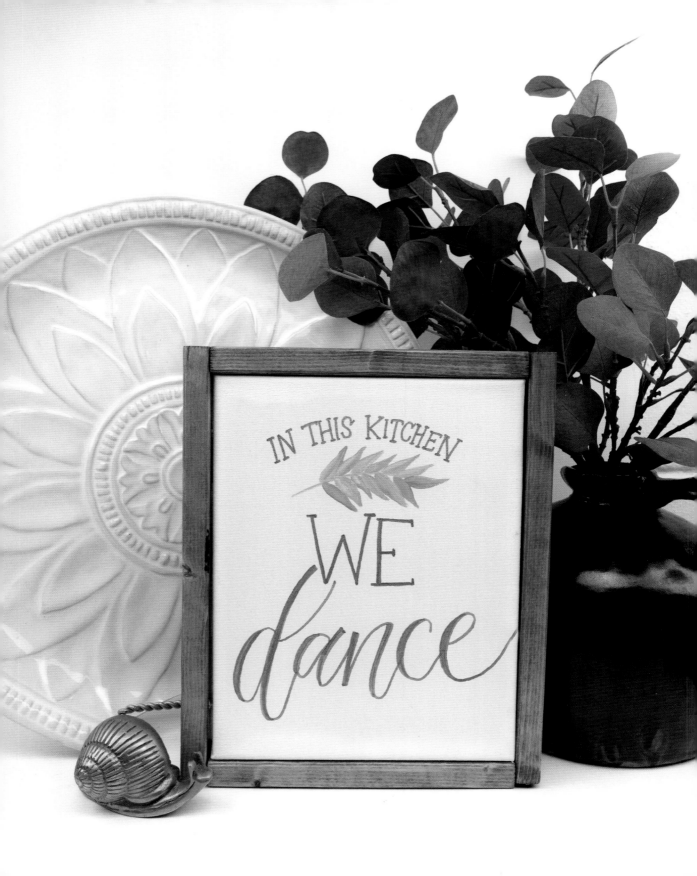

LET'S DANCE

So much happens in our kitchen! A time-lapse video would show my family coming and going, food being eaten (or not), dishes being cleaned (or piled in the sink), bags being packed, and people heading out the door and back in to do it all again. In the midst of our routines, this sign is my reminder to enjoy a moment. If the kitchen is the heart of a home, then it should see some dancing—even if it is a little more freestyle than choreographed.

SUPPLIES

- 2 furring strips, approximately 11½", to frame the canvas*
- 2 furring strips, approximately 7⅞", to frame the canvas*
- Orbital sander, with medium- and fine-grit sanding discs
- Tack cloth
- Microfiber cloth, for stain application
- Minwax Early American stain (or stain of your choice)
- Compass or large round bowl, for creating an arc
- Pencil and white eraser
- Primed stretched canvas, 8" x 10" (or size of your choice)
- Straightedge or triangle
- Gold medium-tip acrylic paint pen
- Light green acrylic paint
- White acrylic paint

- Small detail paintbrush
- Wood glue
- Bar clamps
- Brad nailer and 1¼" finishing brad nails
- Tape measure (optional)
- Small (3") sawtooth hanger, with accompanying nails (optional)
- Hammer (optional)

** Canvas is often slightly smaller than the advertised size, so check the exact measurements before cutting the frame to fit.*

DIRECTIONS

1. **PREP THE WOOD:** Sand the furring strips with medium-grit and then fine-grit sandpaper. (See technique tips on page 58.) Clean the newly sanded strips with the tack cloth.

2. Using the microfiber cloth, apply the stain to the furring strips, following the wood grain.

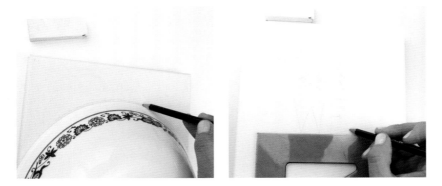

3. **BEGIN THE LETTERING:** Use a compass or a large bowl (as shown) to pencil an arc guideline on the canvas. Use the straightedge or triangle to establish your baseline for the straight print.

4. Lightly pencil the phrase onto the canvas. Erase and rewrite until you are happy with the spacing and shape of the letters. Letter over the pencil guidelines with the gold acrylic paint pen.

Primed canvas is a very forgiving surface when you're a lettering beginner! Use your white eraser to edit out mistakes and get the layout of letters that you want.

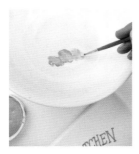

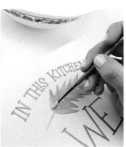
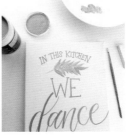

5. **DESIGN THE EMBELLISHMENT:** With a pencil, draw guidelines for the line branch with simple leaves on each side.

6. With the acrylic paint colors, create a palette. I chose light green and white and mixed them for a third, even lighter green color. Layer paint on the leaves, adding white highlights to the wet green paint for variations in each leaf. Follow the photos shown here for inspiration.

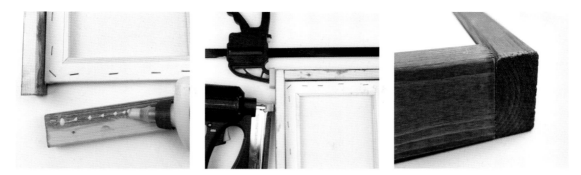

7. **FRAME THE SIGN:** Apply wood glue to the furring strips and attach along the side of the sign board. Use bar clamps to secure in place across the sign. Use the brad nailer to add three finishing nails along each stretch of frame, connecting the sign board to the furring strips. Clean up any glue that might squeeze out with a damp rag.

8. **ADD HANGING HARDWARE:** You can choose to simply hang the sign on the "lip" of the frame. But if you would like to add a sawtooth hanger, use a tape measure to find and mark the top center of your sign board. Center the sawtooth hanger horizontally on the furring strip. With a hammer, carefully tap the two small nails into the board.

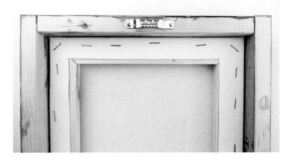

MIX IT UP

A. Design branch borders to frame the text, then letter with a mix of monoline Faux Calligraphy and Cafe Print.

B. Swap out the leaf detail for a wheat illustration, and change the composition by orienting the text to the left.

C. Try lowercase Cafe Print with a monoline Faux Calligraphy for a clean, simple look.

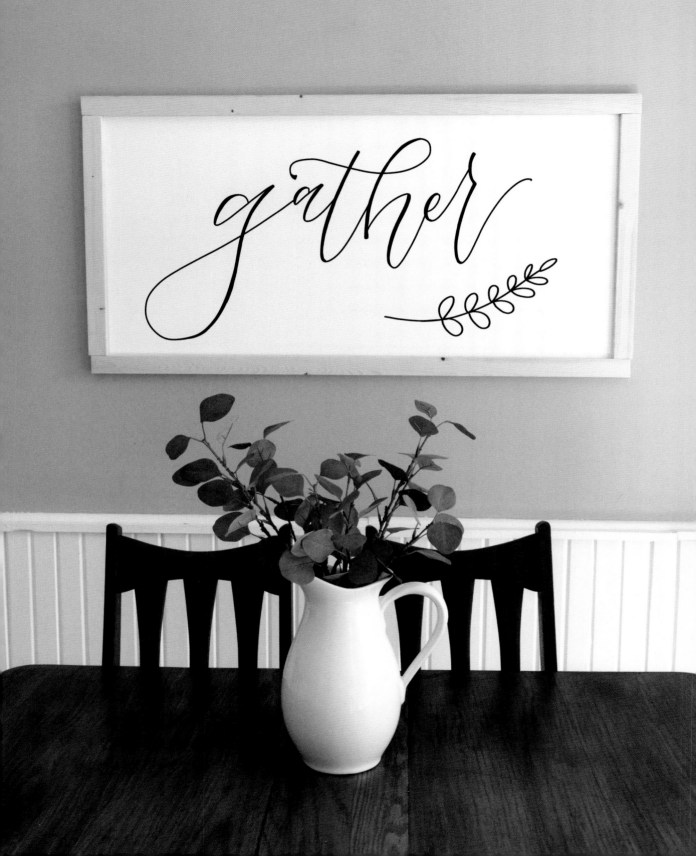

SIMPLY GATHER

Many people associate the word *gather* with autumn and specifically Thanksgiving. But why not always have this simple word on display? For me, it's a reminder that at the close of a busy day, my family can gather back together around our table. This sign is a pledge to make a family meal a priority and to commit to spending the time together fully present, even if it's just before one of us rushes out the door for a practice. Hopefully, this sign can be an invitation for your family as well.

SUPPLIES

- Orbital sander, with medium- and fine-grit sanding discs
- 2 furring strips, 49"
- 2 furring strips, 21½"
- Underlayment plywood panel, 24" x 48"
- Tack cloth
- Paintbrush or small paint roller
- Primer
- White indoor latex paint, flat
- Paper and marker, for practice lettering
- Laser level
- Gray or black chalk
- Black medium-tip acrylic paint pen
- Clean microfiber cloth
- Wood glue
- Spring clamps
- Brad nailer and ⅝" finishing brad nails
- Tape measure
- 2 D-ring hangers, with accompanying screws
- Screwdriver
- Picture wire

DIRECTIONS

1. **PREP THE WOOD:** Sand the furring strips with medium-grit and then fine-grit sandpaper. (See technique tips on page 58.) Clean the newly sanded strips and the piece of underlayment plywood with the tack cloth. Set the furring strips to the side.

2. Using a small paintbrush or paint roller, paint the underlayment board with a layer of primer. (This step will keep the wood grain or knots from bleeding through the white paint.) Allow the primer coat to dry, according to the directions.

3. Using a fresh small paintbrush or paint roller, paint the underlayment board with a layer of white latex paint. Allow the paint to dry, according to the directions.

4. **BEGIN THE LETTERING:** On scrap paper the same length as your underlayment board, write "Gather" in Faux Calligraphy. Practice until you are satisfied with the style and spacing.

5. Line up your practice lettering sheet just above the front side of your board. Using the laser level to establish a baseline for your text, chalk the quote onto the wood.

6. Working slowly, write over your chalk guides with the paint pen, smoothing out any wobbly letters. Allow the paint to dry completely to the touch, and then erase the chalk guidelines with a damp microfiber cloth.

7. "Double up" your downstrokes (see the technique on page 7). Allow the paint to dry and then add another coat of paint to your letters.

As you create hand-lettered signs, you'll discover that black paint pens don't need as many coats of paint as the white ones.

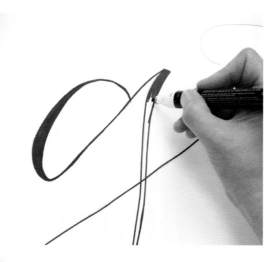

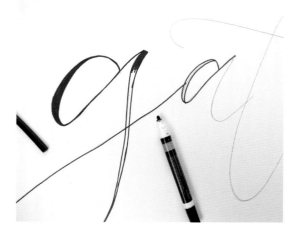

8. **DESIGN THE EMBELLISHMENT:** Working again in steps with chalk and then the paint pen, add the branch accent as shown in the final project on page 100. Use the design at left as your inspiration. Allow the paint to dry completely before the next step of framing.

9. **FRAME THE SIGN:** Apply wood glue to the furring strips, then attach the furring strips along the edge of the underlayment sign board. Clamp the strips in place. Once all four pieces are glued and clamped in place, carefully turn the sign over. Using the brad nailer, add three finishing nails per side, connecting the underlayment board to the furring strips. Clean up any glue that might squeeze out with a damp rag.

10. **ADD HANGING HARDWARE:** Use a tape measure to find and mark 6 inches down from each of the top corners. Attach the D-ring hangers with the screws provided. String the picture wire between the two hangers, twisting the ends of the picture wire to secure them.

MIX IT UP

A. Swap the Faux Calligraphy lettering for the Block Print, and add a small wheat detail.

B. Skip doubling your downstrokes and leave the word *gather* as a monoline. Try extending the letters to the edge of the sign.

C. Modify the Faux Calligraphy to be less bouncy, and use painter's tape to add painted corners to the sign. See page 161 for the details of this process.

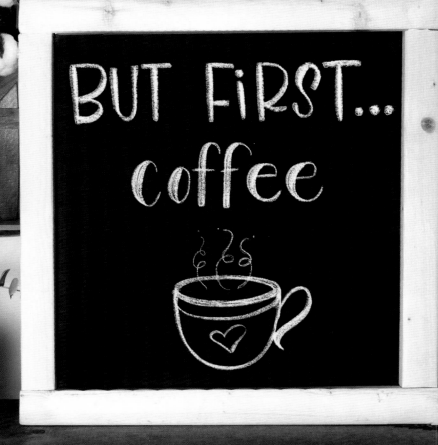

BUT FIRST . . . COFFEE

I have a love/hate relationship with coffee. After periods of time when I cut it out of my daily routine, coffee always seems to win me back when the weather turns cooler. Our strong feelings about coffee are reflected in the many coffee sayings I see on signs and other home decor items! In fact, I had a hard time sticking to just one, so this sign is designed as a chalkboard. That way, you can easily switch up your sign to celebrate the current status of your coffee relationship, or to maybe signal that it's complicated.

SUPPLIES

- Orbital sander, with medium- and fine-grit sanding discs
- 2 furring strips, 16½"
- 2 furring strips, 13½"
- Underlayment plywood, 16" x 16"
- Tack cloth
- Paintbrush or small paint roller
- Primer
- Dense foam paint roller
- Black chalkboard paint
- White chalk
- Clean microfiber cloth
- Paper and marker, for practice lettering
- Painter's tape or laser level
- White medium-tip chalk marker
- Wood glue
- Spring clamps
- Brad nailer and ⅝" finishing brad nails
- Tape measure (optional)
- Large (5") sawtooth hanger, with accompanying nails (optional).

DIRECTIONS

1. **PREP THE WOOD:** With the orbital sander, sand the furring strips with medium-grit and then fine-grit sandpaper. (See technique tips on page 58.) Clean the newly sanded strips and the piece of underlayment plywood with the tack cloth. Set the furring strips to the side.

2. Using the small paintbrush or paint roller, paint the underlayment board with a layer of primer. Allow the primer coat to dry, according to the directions.

3. With fine-grit sandpaper, lightly sand by hand the primed surface of the underlayment board to smooth out any small bubbles or bumps. Remove the dust with the tack cloth.

4. Using the dense foam paint roller, paint the underlayment board with a layer of black chalkboard paint. Allow the paint to dry, according to the directions. Add a second coat of chalkboard paint. Allow the paint to cure, following the directions, before moving on to the next steps.

The recommended time span for curing is usually a few days.

5. **CONDITION YOUR CHALKBOARD:** Simply rub the side of a stick of chalk over the entire surface of the chalkboard, and then erase with the microfiber cloth.

 This step, sometimes called seasoning or priming, distributes a fine layer of dust that settles in the grains. The advantage: Your lettering will stay bright on the surface yet also erase easily when you're ready to start fresh with a new lettering creation.

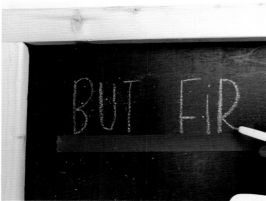

6. **BEGIN THE LETTERING:** On scrap paper the same length as your board, write the sign's phrase in Cafe Print. Practice until you are satisfied with the style and spacing.

7. To help guide your word spacing, line up your practice lettering sheet just above the front side of your board. Use painter's tape, placed with enough space above to write (as pictured), or a laser level to establish a baseline for your text. Chalk your quote onto the blackboard.

Chalkboards are great starter projects. If you're not happy with your lettering, just erase and try again!

8. **DESIGN THE EMBELLISHMENT:** Add the coffee cup accent as shown in the final project on page 104. Use the design at right as your inspiration.

9. **FRAME THE SIGN:** Apply wood glue to the furring strips, then attach the furring strips along the edge of the underlayment board. Clamp the strips in place. Once all four pieces are glued and clamped in place, carefully turn the sign over. Using the brad nailer, add three finishing nails on each side, connecting the underlayment board to the furring strips. Clean up any glue that might squeeze out with a damp rag.

10. **ADD HANGING HARDWARE, IF USING:** Flip the sign over. Use a tape measure to find and mark the center of the top of the frame. With a hammer, carefully tap the two small nails of the sawtooth hanger into the board.

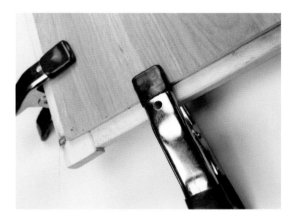

MIX IT UP

A. Shout out to the tea drinkers out there!

B. Block Print, Faux Calligraphy, and Cafe Print mix together nicely for this cute chalkboard. The little smiley face on the coffee cup can be added as a finishing touch.

C. My best friend has the cutest little coffee/wine bar space! I was thinking of her kitchen when I made this version with Faux Calligraphy and Cafe Print.

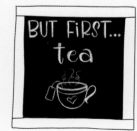
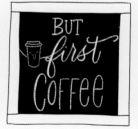

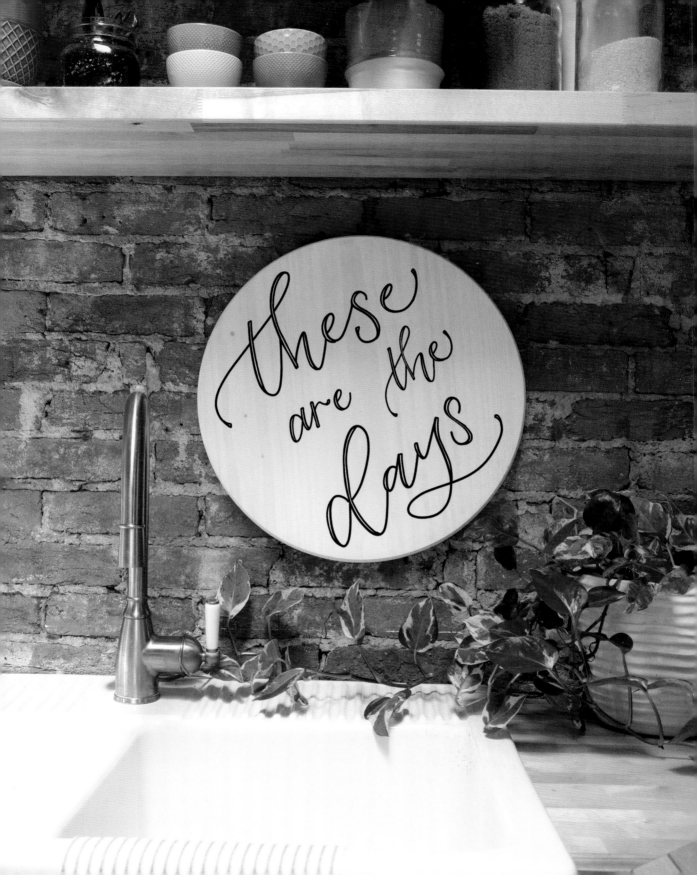

THESE ARE THE DAYS

What a great reminder! We tend to feel so much nostalgia for the past and anticipation and hope for things to come that sometimes it's hard to live in the moment. It can be ironic to read this sign as you wash dish after dish or mop the floor, but honestly, it can also be centering. These little moments make up a life that's full of home, heart, and family. Each dish washed is a reminder to savor family meals and the blessings on your table. Each swipe of the mop is a reminder to be thankful for your family's home and all the activities you enjoy. Live in and appreciate the moments.

SUPPLIES

- Round pine board, 1" thick x 18" diameter
- Tack cloth
- Clean jar with lid
- White indoor latex paint, flat
- Paintbrush
- Paper and marker, for practice lettering
- Laser level
- Gray or black chalk
- Black fine-tip acrylic paint pen
- Clean microfiber cloth
- Tape measure
- Large (5") sawtooth hanger, with accompanying nails
- Hammer

I like to make sure that the wood grain is still visible.

DIRECTIONS

1. PREP THE WOOD: Pine rounds are all ready for paint or stain, so you can skip the sanding. But it's still a good idea to wipe down the round with tack cloth to remove any lingering dust.

2. In a clean container, such as a jar with a lid for easy storage, create a whitewash. Mix two parts white indoor latex paint with one part water. Use a paintbrush to apply the whitewash to the pine round. Paint in the same direction as the wood grain, just like you would apply stain. Choose the number of coats to get the look you love. Allow the paint to dry to the touch.

3. **BEGIN THE LETTERING:** On scrap paper the same width as your pine round, write the sign's phrase in monoline Faux Calligraphy. Practice until you are satisfied with the style and spacing. Add an outline to "double up" the downstrokes, but do not fill in (see the technique on page 7). Erase any overlapping lines.

4. Line up your practice lettering sheet just above the front side of your wood board. Using the laser level to establish a baseline for your text, chalk the quote onto the wood.

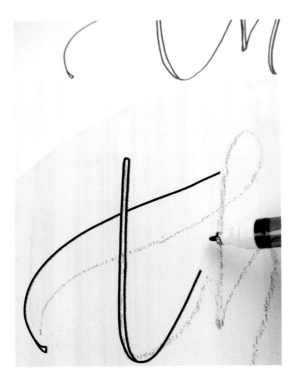

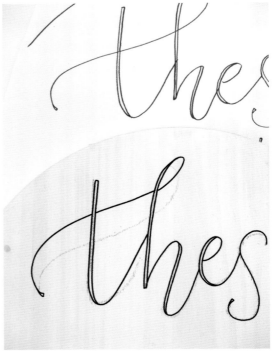

5. Working slowly, write over your monoline chalk guides with the paint pen, smoothing out any wobbly letters. Allow the paint to dry completely to the touch, and then erase the chalk guidelines with a damp microfiber cloth.

You can see from the pictures that I chose to really change the slope of the T.

6. Apply an additional coat of paint to ensure opaque and even letters.

7. **ADD HANGING HARDWARE:** After your paint has completely dried, flip the sign over. Use a tape measure to find and mark the center of your round. Center the sawtooth hanger horizontally and about 2 inches from the top. With the hammer, carefully tap the two small nails into the board.

MIX IT UP

A. Swap Faux Calligraphy lettering for lowercase Cafe Print. Add a small leafy detail.

B. Use a modified monoline Faux Calligraphy. Two leafy details frame the minimalist wording really nicely.

C. Use two styles of lettering (Block Print and Faux Calligraphy). Swap out the black paint pen for a different color for even more emphasis.

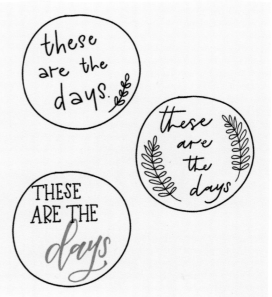

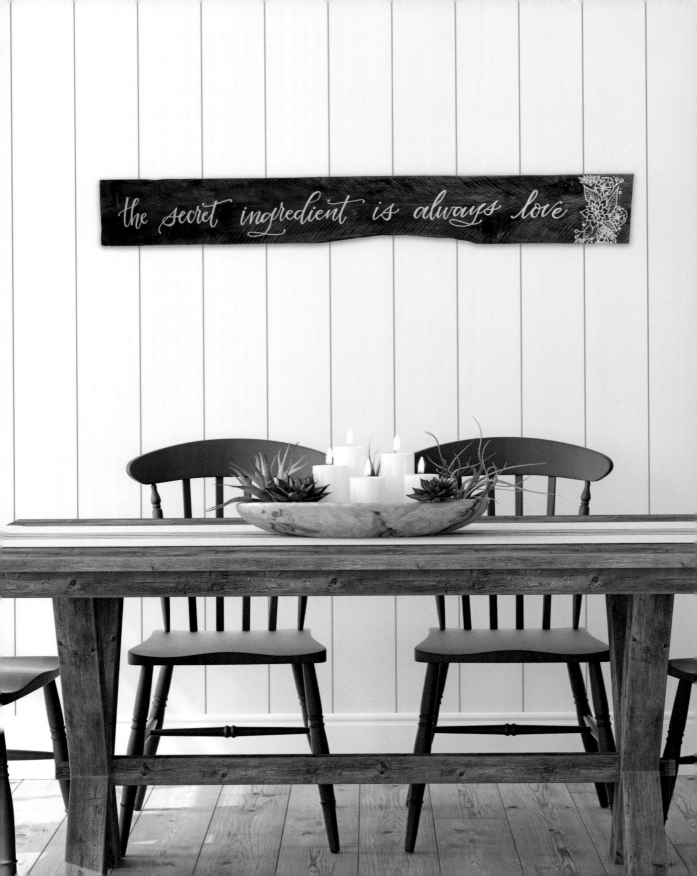

THE SECRET INGREDIENT

When you recall some of your favorite memories, what do they have in common? My guess is *love*. You were probably doing something you love or simply spending time with people you love. Some of my favorite memories: baking holiday treats for large family gatherings, enjoying pancakes and coffee on a weekend morning, or connecting over a late-night dinner after a busy day. I hope that creating and hanging this sign in your kitchen or dining area will encourage you to focus on the love you share as much as it encourages my family.

SUPPLIES

- Pallet wood plank, approximately 1" x 4" x 48"*
- Orbital sander, with coarse-, medium-, and fine-grit sanding discs
- Tack cloth
- Microfiber cloth, for stain application
- Minwax Early American stain (or stain of your choice)
- Paper and marker, for practice lettering
- Laser level
- White chalk
- White medium-tip acrylic paint pen
- Clean microfiber cloth
- Tape measure
- Large (5") sawtooth hanger, with accompanying nails
- Hammer

If you don't have access to a pallet, simply substitute a common wood board from a hardware store.

DIRECTIONS

1. **PREP THE WOOD:** Sand the plank in a progression with coarse-, medium-, and fine-grit sandpaper. (See technique tips on page 58.) Clean the plank with the tack cloth.

2. Using the microfiber cloth, apply the stain to the front of the plank, following the wood grain. Allow the stain to dry, according to the directions.

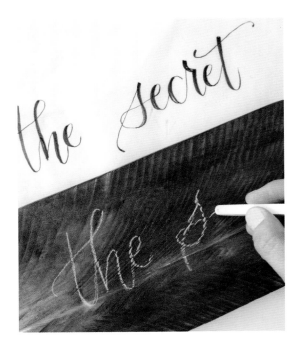

3. **BEGIN THE LETTERING:** On scrap paper the same length as your plank, write the sign's phrase in Faux Calligraphy. Practice until you are satisfied with the style and spacing.

4. Line up your practice lettering sheet just above the front side of your plank. Using the laser level to establish a baseline for your text, chalk the quote onto the wood.

This step helps to avoid the natural downward slope of the words as you letter.

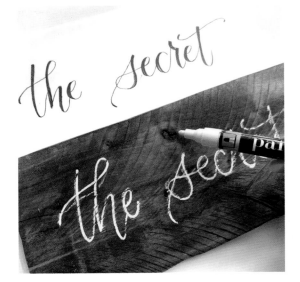

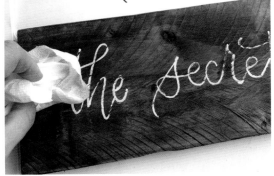

5. Working slowly, write over your chalk guides with the paint pen, smoothing out any wobbly letters. Allow the paint to dry completely to the touch, and then erase the chalk guidelines with a damp microfiber cloth.

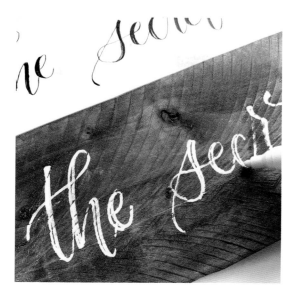

As you step back and look over your lettering, the white words should really pop off of the dark stain.

6. "Double up" your downstrokes (see the technique on page 7). Allow the paint to dry and then add another coat of paint to your letters. Continue adding a total of three or four coats of paint, allowing each coat to dry before starting the next, until you have an opaque covering.

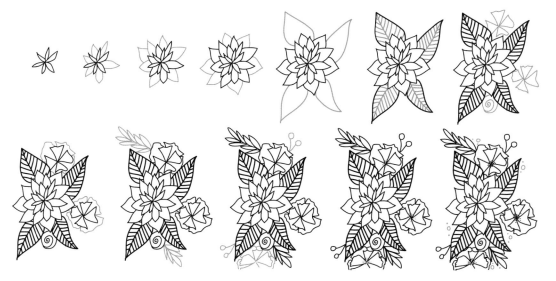

7. **DESIGN THE EMBELLISHMENTS:** Start by adding a large flower in the middle with some smaller flowers on either side. Because these are line drawings, it looks best to not be rigidly symmetrical. Don't focus too much on a flower here, so a flower there. Add leaves and berries to help balance the design. Use the design progression above as your inspiration.

8. **ADD HANGING HARDWARE:** After your paint has completely dried, flip the sign over. Use a tape measure to find and mark the center of your plank. Center the sawtooth hanger horizontally and about 1 inch down from the top. With the hammer, carefully tap the two small nails into the board.

MIX IT UP

A. Swap the Faux Calligraphy lettering for the Cafe Print. Use size to emphasize certain words.

B. Keep the Faux Calligraphy but introduce a floral bottom border.

C. Try mixing fonts. Using mostly Block Print while featuring "love" in Faux Calligraphy is a fun approach.

5

SWEET DREAMS FOR BEDROOMS

TO THE MOON

I see this quote everywhere but did not really understand its meaning until I read the children's book *Guess How Much I Love You*. A precious small hare tries over and over to express love in the largest way and ultimately tells the large hare that he is loved to the moon, thinking that is the farthest distance you can measure. But after the small hare falls asleep, the large hare whispers, "I love you to the moon . . . and back." This book is one of our family's favorite bedtime stories. If it's close to your heart too, you'll appreciate this sign. Or feel free to sub in a quote that holds special meaning to you and your little one!

SUPPLIES

- Paper and marker, for practice lettering
- Primed round stretched canvas, 12" diameter*
- Laser level
- Pencil and white eraser
- Black fine-tip acrylic paint pen
- Scissors
- 1 sheet cream felt**
- Hot glue gun
- Decorative button
- 1 sheet pink felt
- 1 sheet green felt
- Round wooden embroidery hoop for the frame, 12"
- 2' brown twine ribbon, or ribbon of your choice

* *Canvas rounds can be purchased from online craft supply stores. You can also substitute the round canvas for a more widely available rectangle, like the one shown on this book's cover.*

** *These are usually found in 9" x 12" sheets. One sheet of each color is plenty.*

DIRECTIONS

1. **BEGIN THE LETTERING:** On scrap paper the same width as your canvas round, write the sign's phrase in a combination of Faux Calligraphy and Block Print. Practice until you are satisfied with the style and spacing. Leave space on the lower right-hand side for the felt florals.

2. Line up your practice lettering sheet to the left of the canvas. Using the laser level to establish a baseline for your text, lightly pencil your quote onto the canvas.

3. Working slowly, write over your pencil guides with the paint pen, smoothing out any wobbly letters. Allow the paint to dry completely to the touch, and then erase the pencil guidelines with the eraser.

4. "Double up" your downstrokes (see the technique on page 7). Add one more additional coat of paint to ensure uniform, opaque letters.

5. **DESIGN THE EMBELLISHMENTS:** To create the cream flower, cut out 4 felt flower shapes using the template below.

6. Place a dot of hot glue in the center of each flower and fold in half. Carefully press each flower for 5 seconds while the glue cools. Then turn the flower halves so that the crease faces the middle. Glue each of the four pieces together so that each piece is over the flower to its left and under the flower to its right. Think of a box closure. Finish the flower by securely gluing or stitching a pretty button in the center. Set aside.

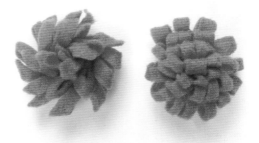

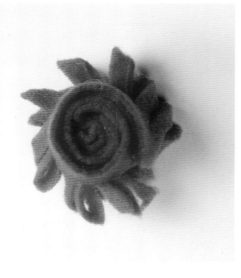

If you cut straight the result will look like the flower on the right. Cut angled and you'll get the style on the left.

7. To create the pink flowers, cut out a rectangular strip of felt 9 inches long by 1½ inches wide. Fold the strip in half. Cut straight or angled lines from the center crease to about ¼ inch from the edge. While the strip is still folded in half, roll into a spiral and glue in place. Set aside.

8. To create the leaves, cut the green felt as pictured or in your desired shape. Glue the leaves first as the base of the flowers, and then add the flowers.

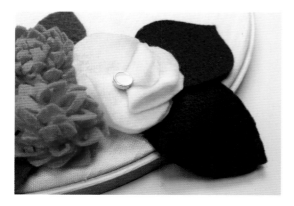

9. **FRAME WITH A HOOP:** Place the embroidery hoop around the canvas. Tighten by turning the pin at the top.

10. Measure and mark one-third from the top of the circle. Hot glue the ribbon to either side. Allow the glue to dry before picking up the sign by the ribbon.

11. When the glue is dry, you're ready to hang the sign on a small nail or tack in the wall. It's lightweight, so no drywall screws are needed.

MIX IT UP

A. Swap Cafe Print in for the lettering. Place the flowers as an arch at the top.

B. Replace the felt flowers with felt or painted mountains and a moon.

C. Try painting a linear pattern with painter's tape (learn the technique on page 161). Then letter with a mix of Faux Calligraphy and Cafe Print.

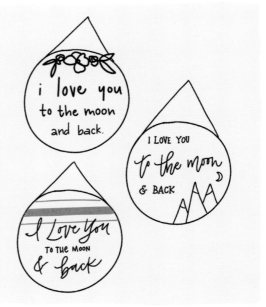

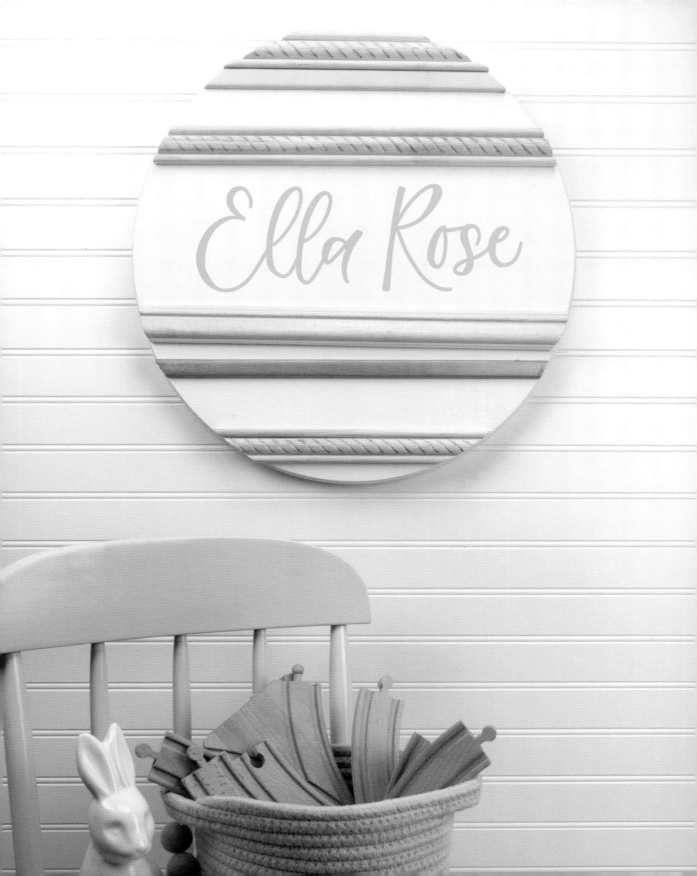

PRECIOUS NAME

A family name? A book character or favorite place? An epic (or funny) moment of inspiration? Or a name that just somehow fit? I love to hear the origin of and meaning behind given names. Name signs make beautiful room decor but usually come in at a high price point. Good thing it's simple to make your own affordable version and enjoy even more design possibilities. This sign is the best of DIY, with fun texture and easily customizable pops of color. It makes a great statement piece in a bedroom.

SUPPLIES

- 3 chair rail molding pieces, 2' long*
- Round pine board, 1" x 18"
- Saw (A miter saw makes the work easy, but a hand saw will work as well.)
- Medium- and fine-grit sandpaper
- Tack cloth
- Small paintbrushes
- Indoor latex paint samples, variety of colors
- Primer
- White indoor latex paint, flat
- Wood glue
- Spring clamps (optional)
- Paper and pencil, for lettering transfer
- Painter's tape
- Fine-tip acrylic paint pen, your choice of color
- Tape measure
- Large (5") sawtooth hanger, with accompanying nails
- Hammer

These can be bought by the length at hardware stores. I recommend mixing three different patterns/details.

DIRECTIONS

1. **PREP THE WOOD:** Lay the chair rail pieces on the wood round and mark your cutting lines. With a saw, cut the pieces to fit the circle, then sand the pieces with medium-grit and then fine-grit sandpaper to smooth the edges. (See technique tips on page 58.) Clean the boards with the tack cloth. Then paint the pieces with various colors of indoor latex paint. Leave a few unfinished if you like, as I did.

2. Pine rounds are all ready for paint or stain, so you can skip the sanding. But it's still a good idea to wipe down the round with tack cloth to remove any lingering dust. Using a paintbrush, apply a primer coat and allow it to dry, according to the directions. Then apply the white paint and allow it to dry, according to the directions.

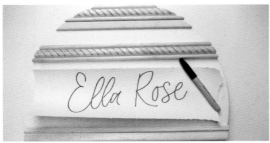

3. Place the chair rail pieces on the wood round to double-check their placement. Then attach each piece with wood glue. Use clamps or place a weight on the pieces until dry. Clean up any glue that might squeeze out with a damp rag.

4. **BEGIN THE LETTERING:** For a sign like this with little text, I would use the transfer method described in the introduction (see page 66). On scrap paper and using Faux Calligraphy, write the name exactly as you would like the lettering to look on the sign.

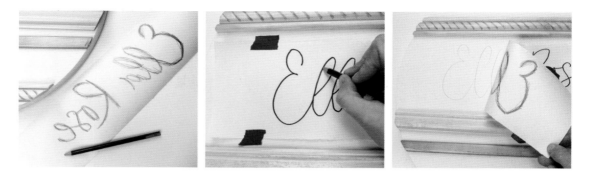

5. Flip the lettering over, then darken the back of the letters completely with pencil. Flip the lettering back over and place on the sign. Use painter's tape to secure it in place. With the pencil, trace over the letters slowly and firmly. This method will transfer the letters to the wood.

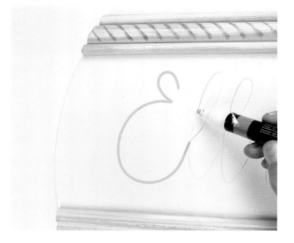

6. Remove the paper and trace over the letters with the colored paint pen. Allow the paint to dry, then add one more coat of paint over each letter.

7. **ADD HANGING HARDWARE:** After your paint has completely dried, flip the sign over. Use a tape measure to find and mark the center of your round about 2 inches from the top. Center the sawtooth hanger horizontally and with the hammer, carefully tap the two small nails into the board.

MIX IT UP

A and B. Switch up the direction of your chair rail pieces. These configurations call for more wood cuts.

C. Opt for a mix of lettering styles.

From the paint pen to the moulding paints, there are so many ways to play with colors to make this sign yours! For a completely different color approach, attach your chair rail pieces and then paint the entire sign (chair rails and wood round) white or black.

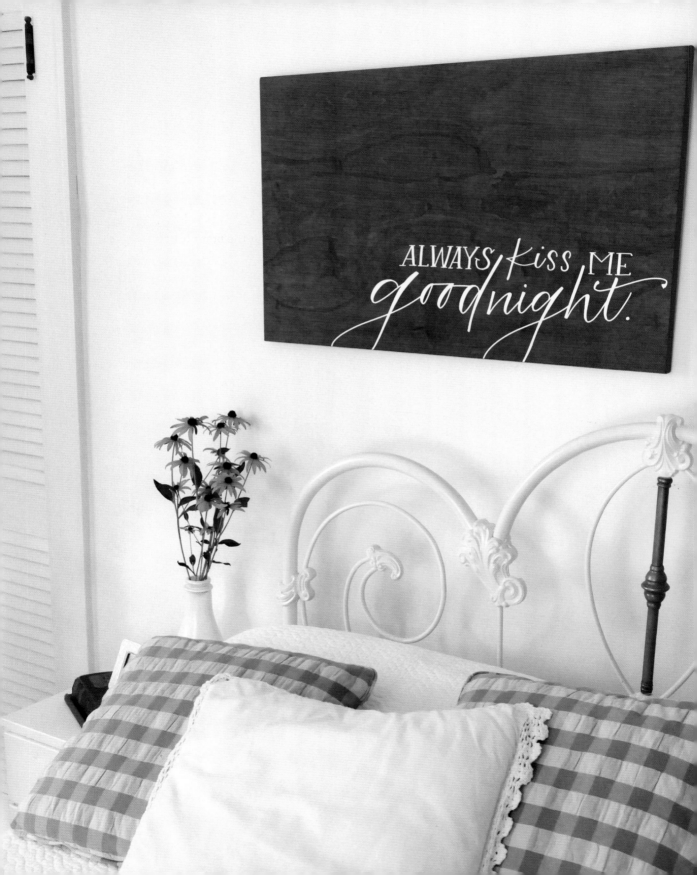

KISS ME GOODNIGHT

Bedrooms should be sanctuaries. I can weather a little chaos around me in the rest of the house, as long as my bedroom is calm and neat. It's my tranquil ending to the day. To add warmth and peace to your bedroom, bring in this simple and sweet project. The minimal design leaves negative space to really showcase that warm, dark wood. This quote is great for a master bedroom, but for a more universal quote (for a guest room), omit the first part of the phrase and simply letter "goodnight"!

SUPPLIES

- ¾" birch plywood board, 24" x 48"
- Tack cloth
- Microfiber cloth, for stain application
- Minwax Dark Walnut stain
 (or stain of your choice)
- Paper and marker, for practice lettering
- Painter's tape
- Laser level
- White chalk
- White medium-tip acrylic paint pen
- Clean microfiber cloth
- Tape measure
- 2 D-ring picture hangers
- Screwdriver
- Picture wire

DIRECTIONS

1. **PREP THE WOOD:** Wipe down the board with tack cloth to remove any lingering dust. Using the microfiber cloth, apply the stain to the front of the board, following the wood grain. Allow the stain to dry, according to the directions.

2. **BEGIN THE LETTERING:** On scrap paper the same dimensions as your board, write the sign's phrase in a combination of Block Print and Faux Calligraphy. Practice until you are satisfied with the style and spacing.

3. Line up your practice lettering sheet about halfway down the board. Because this sign utilizes negative space and the lettering is only in the bottom right part of the sign, you can use painter's tape to secure your sheet to the middle of the board. Using the laser level to establish a baseline for your text, chalk the quote onto the wood.

I recommend lettering "goodnight" first and then filling in "always kiss me" above for the best spacing.

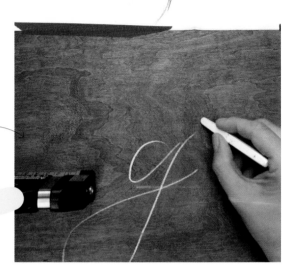

4. Working slowly, write over your chalk guides with the paint pen, smoothing out any wobbly letters. Allow the paint to dry completely to the touch, and then erase the chalk guidelines with a damp cloth.

5. "Double up" your downstrokes for the Faux Calligraphy (see the technique on page 7). Allow the paint to dry, and then add another coat of paint to all of the letters. Continue adding a total of three or four coats of paint, allowing each coat to dry before starting the next, until you have an opaque covering.

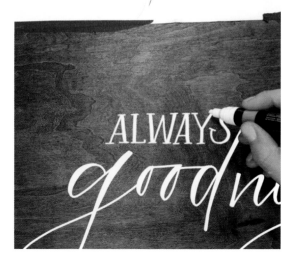

Expect to add at least three coats of paint to the letters for such a dark-stained sign.

6. ADD HANGING HARDWARE: Once the paint is dry, flip the sign over. Use a tape measure to find and mark 6 inches from the top of each corner of the sign. Attach the D-ring hangers with the screws provided. String the picture wire between the two hangers and twist to secure it in place.

MIX IT UP

A. Letter simply "goodnight" in monoline Faux Calligraphy.

B. Add a floral swag.

C. I know the minimal look isn't for everyone, so here's an option if you love a bit more flare. Add an explosion of flowers in the left-hand side and feature Faux Calligraphy centered across the bottom.

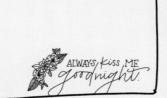

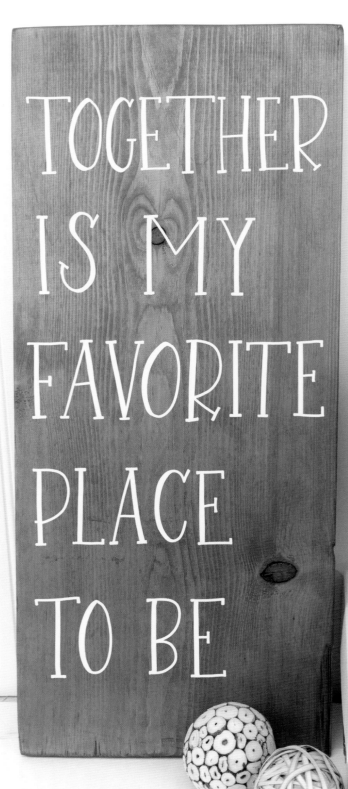

TOGETHER
IS MY
FAVORITE
PLACE
TO BE

MY FAVORITE PLACE

I love to travel, seeing new places and experiencing new things. To remind me of those adventures, I spread travel photos throughout my home. But the photos I choose to display aren't focused on the beautiful buildings and spaces I visited. Instead, I cherish those silly selfies of people I love trying to scrunch in to document a moment in time together. My favorite moments are not attached to the places but to the people I am with. This sign is beautiful reminder of that fact.

SUPPLIES

- Orbital sander, with medium- and fine-grit sanding discs
- Common board, 1" x 12" x 18"
- Tack cloth
- Microfiber cloth, for stain application
- Minwax Classic Gray stain (or stain of your choice)
- Paper and marker, for practice lettering
- Painter's tape
- White chalk
- White fine-tip acrylic paint pen
- Clean microfiber cloth
- Tape measure
- Large (5") sawtooth hanger, with accompanying nails
- Hammer

DIRECTIONS

1. **PREP THE WOOD:** Sand the wood board with medium-grit and then fine-grit sandpaper. (See technique tips on page 58.) Clean the wood with the tack cloth.

"Simple" signs like this block text design sometimes take more planning and care with measurements than more embellished signs. With embellished signs you can always add balance after the letters with carefully placed florals or geometric lines. For this text-only sign, use the painter's tape and the tape measure to ensure that the spacing is consistent between lines of lettering and that the size of the letters across each word stays the same!

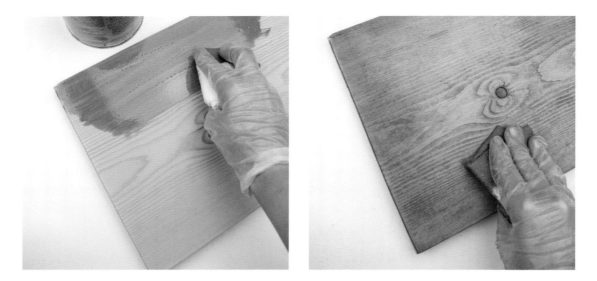

2. Using the microfiber cloth, apply the stain to the front of the wood board, following the wood grain. Allow the stain to dry, according to the directions.

3. **BEGIN THE LETTERING:** On scrap paper the same dimensions as your board, write the sign's phrase in Block Print. Practice until you are satisfied with the style and spacing.

4. Line up your practice lettering sheet to the left of the board. To help with spacing and to keep letter heights consistent, block off the board into work lines using painter's tape and chalk the letters in between the tape, working line by line. When you are happy with the letters and spacing, remove the painter's tape and switch to the paint pen.

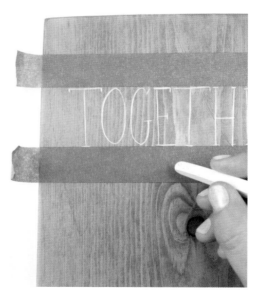

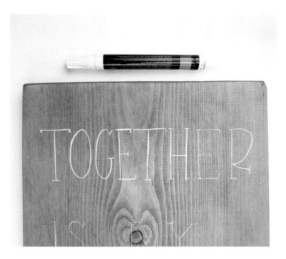

5. Working slowly, write over your chalk guides with the paint pen, smoothing out any wobbly letters. Allow the paint to dry completely to the touch, then erase the chalk guidelines with a damp cloth.

6. "Double up" your downstrokes for the Block Print letters (see the technique on page 7). Allow the paint to dry and then add another coat of paint to all of the letters. Continue adding a total of three or four coats of paint, allowing each coat to dry before starting the next, until you have an opaque covering.

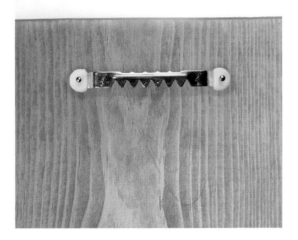

7. **ADD HANGING HARDWARE:** After your paint has completely dried, flip the sign over. Use a tape measure to find and mark the top center of your board. Center the sawtooth hanger horizontally and about 1 inch down from the top. With the hammer, carefully tap the two small nails into the board.

I stain the backs of my plank signs. It's an optional step, but I think it gives a more polished and complete look.

MIX IT UP

A. Swap out Block Print for Cafe Print.

B. Give it a flourish with monoline Faux Calligraphy.

C. Try a combination of Block Print and monoline Faux Calligraphy to emphasize certain words.

TOGETHER iS My FAVORITE PLACE TO BE

together is my favorite place to be

TOGETHER is my FAVORITE PLACE to be

6

WASHING IN FARMHOUSE STYLE

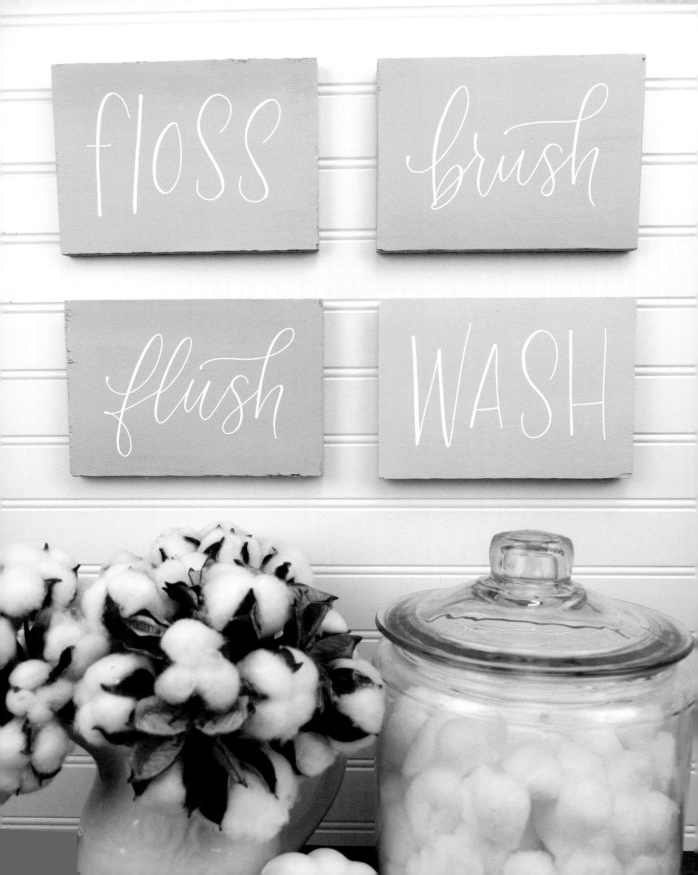

FLOSS, BRUSH, FLUSH, WASH

Simple. Informative. For all ages. I love these silly little "instruction" signs. The design is minimal but so versatile to dress up a wall. Beyond the bathroom, use the basic sign steps to create any kind of "tiled" wall display throughout your home. Just swap in four words that work together in the space intended: maybe love-laughter-family-home for a gathering space or rest-relax-breathe-be for a master bedroom.

SUPPLIES

- Orbital sander, with medium- and fine-grit sanding discs
- 4 pieces hardwood plywood, 1" x 5" x 7"*
- Tack cloth
- 2 small paintbrushes
- Primer
- Coarse-, medium-, and fine-grit sandpaper, for hand sanding
- Gray indoor latex paint, flat (I chose Behr Dolphin Fin)
- Paper and pencil, for lettering practice
- Laser level
- Painter's tape
- White chalk
- White fine-tip acrylic paint pen
- Clean microfiber cloth
- Tape measure
- 4 small (3") sawtooth hangers, with accompanying nails
- Hammer

You can substitute a 1" x 6" board cut into 4 pieces. They are commonly sold in 8' lengths.

DIRECTIONS

1. **PREP THE WOOD:** With the orbital sander, smooth the edges of each board with medium-grit and then fine-grit sandpaper, focusing on the cut edges. (See technique tips on page 58.) Clean the boards with the tack cloth.

2. Paint the face of each of the boards with a layer of primer. Allow the primer coat to dry, according to the directions. Lightly sand the primed surface by hand to smooth out any small bubbles or bumps.

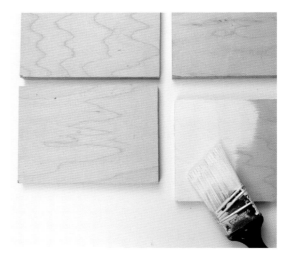

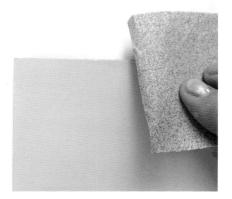

3. Paint the boards with a layer of gray latex paint. Allow the paint to dry, according to the directions.

4. If desired for style, distress the edges of the boards. Hand sand using coarse-grit sandpaper until the grain shows through on each of the four edges.

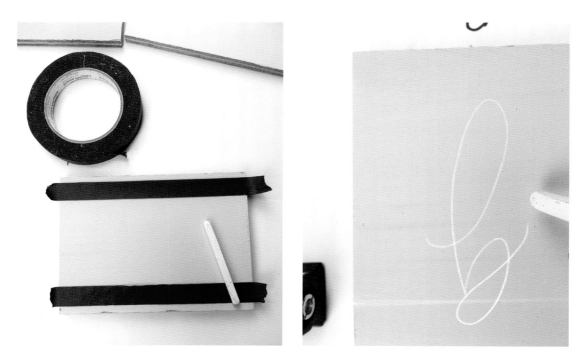

5. **BEGIN THE LETTERING:** On scrap paper the same length as your boards, write the sign's words in a mix of Cafe Print and Faux Calligraphy. Practice until you are satisfied with the style and spacing.

6. Line up each practice lettering sheet just above the front side of your boards. Use the laser level to establish a baseline for your text. For print lettering, I use painter's tape as my top and bottom guides. Chalk the words onto the wood.

7. Working slowly, write over your chalk guides with the paint pen, smoothing out any wobbly letters. Allow the paint to dry completely to the touch, then erase the chalk guidelines with a damp microfiber cloth.

8. **ADD HANGING HARDWARE:** After your paint has completely dried, flip the signs over. Use a tape measure to find and mark the top center of each sign. Center the sawtooth hanger horizontally and about ½ inch down from the top. With the hammer, carefully tap the two small nails into the board.

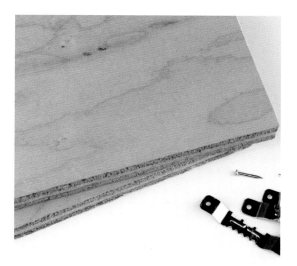

MIX IT UP

Try each of the lettering styles! Mix and match your favorites.

A. Block Print

B. Modified monoline Faux Calligraphy

C. Cafe Print

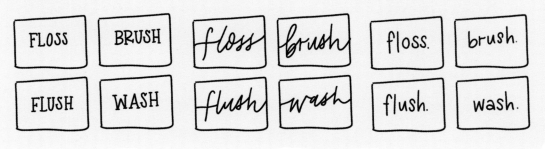

SPLISH SPLASH
take a bath

SPLISH SPLASH

I have a confession to make: I'm just not a bath person. I would much rather relax in my bed with a book. But my kids *love* bath time and could easily spend an hour in the tub. They ask for bubbles, pile in toys, pour water, "swim," and splash around. It's a really sweet playtime for them. So this design is dedicated to Maddie and Ellie and all the bath lovers out there who look forward to "tubby time" and soaking away the cares of the day.

SUPPLIES

- Orbital sander, with medium- and fine-grit sanding discs
- 4 furring strips, cut to frame the canvas*
- Tack cloth
- Microfiber cloth, for stain application
- Minwax Early American stain (or stain of your choice)
- Paper and pencil, for lettering practice
- Stretched primed canvas, 12" x 12" (or size of your choice)
- Triangle or straightedge
- Laser level
- White eraser
- Colorful medium-tip acrylic paint pen (I chose a mint color)
- Wood glue
- Bar clamps
- Brad nailer and 1¼" finishing brad nails
- Tape measure (optional)
- Large (5") sawtooth hanger, with accompanying nails (optional)
- Hammer (optional)

* *Be sure to measure before cutting; canvas sizes tend to be slightly smaller than the advertised size.*

DIRECTIONS

1. **PREP THE WOOD:** Sand the furring strips with medium-grit and then fine-grit sandpaper. (See technique tips on page 58.) Clean the newly sanded strips with the tack cloth.

2. Using the microfiber cloth, apply the stain to the furring strips, following the wood grain. Set the furring strips aside to dry.

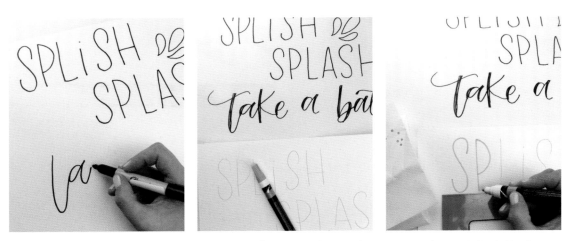

3. **BEGIN THE LETTERING:** On scrap paper the same size as the canvas, plan out the lettering in a mix of Cafe Print and Faux Calligraphy. Practice until you are satisfied with the style and spacing.

4. Line up your practice lettering sheet just above the front side of your canvas. Use the triangle or straightedge to establish your baseline for the Cafe Print. Use the laser level for the baseline of the Faux Calligraphy. Lightly pencil the lettering on the canvas. Erase and rewrite until you are happy with the spacing and shape of the letters.

5. Working slowly, write over your pencil guides with the paint pen, smoothing out any wobbly letters. Allow the paint to dry completely to the touch. Erase any visible pencil guidelines with the white eraser.

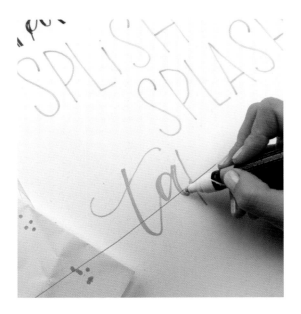

6. "Double up" your downstrokes (see the technique on page 7). Allow the paint to dry and then add additional coats of paint until you have consistent, opaque letters.

7. **DESIGN THE EMBELLISHMENTS:** Add the water droplets in sets of three. Use a simple teardrop shape, but try to make each vary slightly in size or orientation, as in the sample illustration below.

8. **FRAME THE SIGN:** Apply wood glue to the furring strips. Then attach the furring strips along the sides of the sign board. Use bar clamps to secure in place across the sign. Use the brad nailer to add three finishing nails along each stretch of frame, connecting the sign board to the furring strips. Clean up any glue that might squeeze out with a damp rag.

9. **ADD HANGING HARDWARE:** You can choose to simply hang the sign on the "lip" of the frame. But if you would like to add a sawtooth hanger, use a tape measure to find and mark the center of the top furring strip. Center the sawtooth hanger horizontally on the furring strip. With a hammer, carefully tap the two small nails into the strip.

MIX IT UP

A. Add a cute whale graphic along with the water droplets.

B. Use Faux Calligraphy, dropping the second part of the phrase, for a more sophisticated sign.

C. Try Block Print and mix in lowercase for an older kids' bathroom.

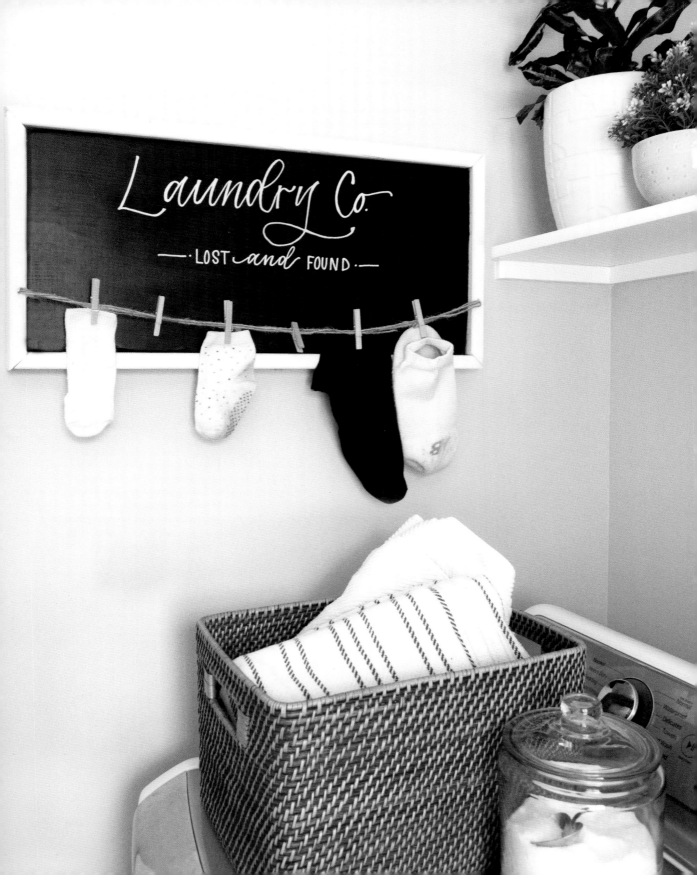

LAUNDRY LOST & FOUND

No matter what laundry system I put in place, I am always finding single socks at the end of my folding pile. It seems to be a fact of life for me. So rather than have a sad stash on top of the dryer, I made this cute sign to display them. I love the organization and touch of whimsy this sign brings to our family's laundry space. Hopefully, it will lead to more matches in the future!

SUPPLIES

- Orbital sander, with medium- and fine-grit sanding discs
- 4 furring strips for frame, mitered edges, cut to surround the edges (see diagram at bottom right)
 - 2 cut to 20½" shortest corner to corner
 - 2 cut to 10" shortest corner to corner
- Common board, 1" x 10" x 20½"
- Tack cloth
- 2 small paintbrushes or paint rollers
- Primer
- Fine-grit sandpaper, for hand sanding
- White indoor latex paint, flat for frames
- Black indoor latex paint, satin for board*
- Paper and marker, for practice lettering
- Laser level
- White chalk
- White fine-tip acrylic paint pen
- Clean microfiber cloth
- Painter's tape
- Wood glue
- Bar clamps
- Brad nailer and 1¼" finishing brad nails

- 2 eye screws, ½"
- Twine
- 5 clothespins
- Tape measure
- 2 D-rings, with accompanying nails
- Screwdriver
- Picture wire

* *Usually I prefer flat paint for signs, but a satin finish makes sense for a sign that will get touched often. The satin is very durable and wipeable.*

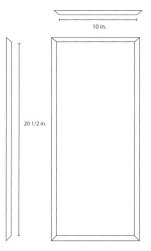

10 in.

20 1/2 in.

DIRECTIONS

1. **PREP THE WOOD:** Using the orbital sander, sand the furring strips and cut edges of the common board with medium-grit and then fine-grit sandpaper. (See technique tips on page 58.) Clean the newly sanded strips and the common board with the tack cloth.

2. Using a paintbrush, paint the board and three sides of the furring strips with primer. Allow the primer coat to dry, according to the directions.

3. Lightly hand sand the primed surfaces with fine-grit sandpaper. Remove any dust with the tack cloth.

4. Paint a layer of white latex paint over the primed furring strips. Set the furring strips aside to dry.

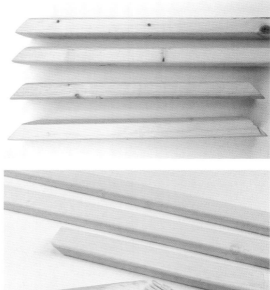

5. Using a small paint roller or paintbrush, apply a layer of black latex paint to the board. Allow the paint to dry, according to the directions.

6. **BEGIN THE LETTERING:** Using a combination of Faux Calligraphy and Cafe Print, write each line's phrase on a scrap paper the same length as your board. Practice until you are satisfied with the style and spacing.

7. Line up your practice lettering sheet for the top line just above the front side of your board. Using the laser level to establish a baseline for your text, chalk your quote onto the board.

8. Working slowly, write over your chalk guides with the paint pen, smoothing out any wobbly letters. Allow the paint to dry completely to the touch, then erase the chalk guidelines with a damp microfiber cloth.

9. Use painter's tape to create guidelines for the second line of print lettering. For this smaller line, you can chalk the letters to create guides again or move right to the lettering with simply your practice sheet as a guide. When you're ready, paint the letters with the fine-tip paint pen. Allow the first coat to dry.

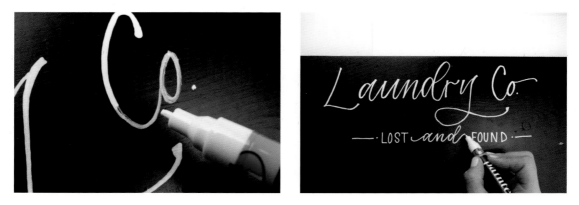

10. Add at least two more coats of paint to make sure that these white letters really pop off of the black wood.

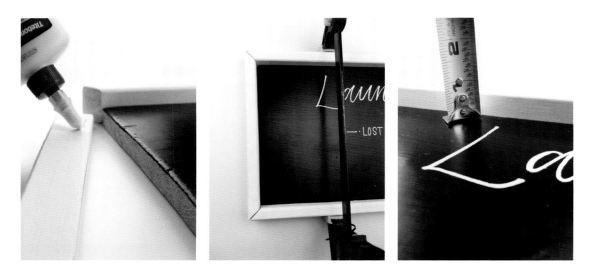

11. **FRAME THE SIGN:** To save space for the sock clothesline, attach the frame with the sign facing up. This approach will make the back of the sign flush with the back of the furring strips and leave a ¾-inch lip above. Apply wood glue to the edge of the wood board. Attach the furring strips along the side of the sign board. Use bar clamps to secure in place across the sign.

12. Use the brad nailer to add three finishing nails along each stretch of frame, connecting the sign board to the furring strips. Clean up any glue that might squeeze out with a damp rag.

Remember that the framing process is time intensive but so worth a sturdy, durable framed sign!

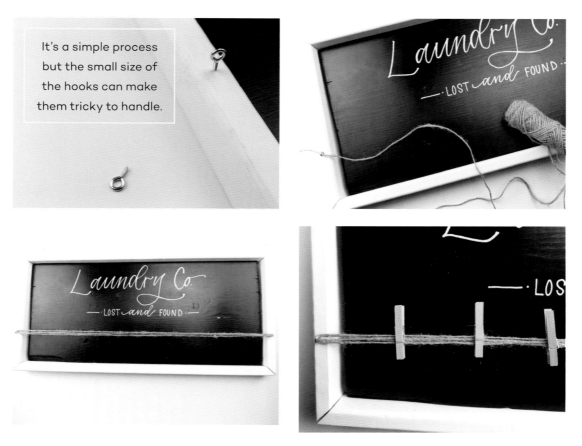

It's a simple process but the small size of the hooks can make them tricky to handle.

13. ATTACH THE CLOTHESLINE: Screw the eye screws into the short sides of the front of the frame the same distance from the bottom of the frame. Loop the twine back and forth four times through the hooks. Tie the twine into a knot to secure. Place clothespins on the line, hiding the knot with one.

Because the clothesline on the sign will get handled when adding and removing socks, it's a smart idea to add D-ring hangers and picture wire to the back.

14. ADD HANGING HARDWARE: Once the frame is dry, flip the sign over and use a tape measure to find and mark 6 inches from the top of each corner of the sign. Attach the D-ring hangers with the screws provided. String the picture wire between the two hangers and twist to secure it in place.

MIX IT UP

A. Swap the lettering styles, using Cafe Print for "Laundry Co." and Faux Calligraphy for "Lost and Found."

B. Try Block Print lettering with a leaf swag detail.

C. Get fancy with Faux Calligraphy and a left-oriented composition rather than centered text.

CELEBRATIONS & GIFT GIVING

COUPLE CONGRATULATIONS

Couple name signs make thoughtful personalized gifts to mark milestones—engagements, weddings, or anniversaries. This project uses a store-bought (or thrift-found) frame, so it's relatively simple but easily customizable. I used a classic thin black frame, but you can find one with more details or color depending on the couple's likes and home decor. The design can also be adapted to include other family members, such as children and fur friends!

SUPPLIES

- Orbital sander, with fine-grit sanding discs
- Underlayment plywood, cut to fit a frame*
- Tack cloth
- 2 paintbrushes or paint rollers
- Primer
- White indoor latex paint, flat
- Paper and marker, for practice lettering
- Pencil, for lettering transfer
- Painter's tape
- Black fine-tip acrylic paint pen
- Black medium-tip acrylic paint pen
- Ruler or triangle for ink
- Frame
- Wood glue

The one used in this project has a 16" x 20" opening.

DIRECTIONS

1. **PREP THE WOOD:** Lightly sand the cut edges of the underlayment plywood. Clean with the tack cloth.

2. Using a small roller or brush, apply a layer of primer to the underlayment board. (This step will keep the wood grain or knots from bleeding through the white paint.) Allow the primer coat to dry, according to the directions.

3. Using a small roller or brush, apply a layer of white latex paint to the underlayment board. Allow the paint to dry, according to the directions.

4. **BEGIN THE LETTERING:** For a sign with just two names, use the transfer method described in the introduction (see page 66). This method allows you to plan the layout and place the names exactly as you want them before writing with paint. On a piece of paper, use marker to write the names exactly as you would like the Faux Calligraphy lettering to look on the sign.

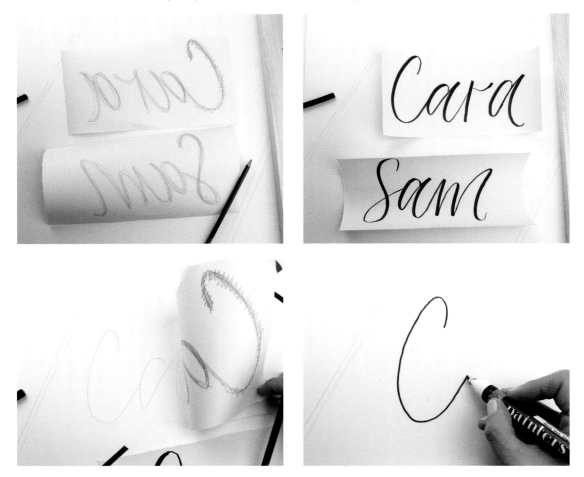

5. Flip the lettering over, then darken the back of the letters completely with pencil. Flip the lettering back over and place the paper on the sign. Arrange the composition, using the painter's tape to secure in place. With the pencil, trace over the letters slowly and firmly. This method will transfer the letters to the wood. Remove the paper and trace over the letters with the medium-tip paint pen. Allow the paint to dry.

6. "Double up" your downstrokes (see the technique on page 7). Allow the paint to dry, then add one more coat of paint over each letter.

7. **DESIGN THE EMBELLISHMENTS:** Use an ink ruler to draw diagonal lines separating the corners of the sign. With the fine-tip paint pen, fill in the bordered corner areas with flowers. Use the illustrations at right as inspiration. Begin with large flowers, then fill in with leaves and small roses. End the designs at the lines, cutting off the edges of the flowers and leaves.

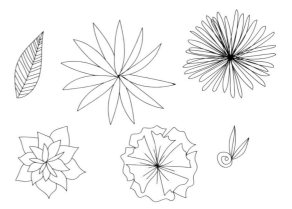

8. **GLUE TO THE FRAME:** Flip over the frame so that the outside is facing down. Apply dots of wood glue along the back lip (where the glass rests). Place the wood sign face down and glue in place. Add weight to the back of the sign (a book works great here!) until the glue dries. Clean up any glue that might squeeze out with a damp rag.

MIX IT UP

A. Keep the same lettering, but skip the flowers. Leave the simple geometric lines for more contemporary styling.

B. Go even more modern with bold Cafe Print names and a monoline Faux Calligraphy "and."

C. Letter the names in Faux Calligraphy, and use Cafe Print for "and." Add children's (or pets') names in smaller Cafe Print at the bottom.

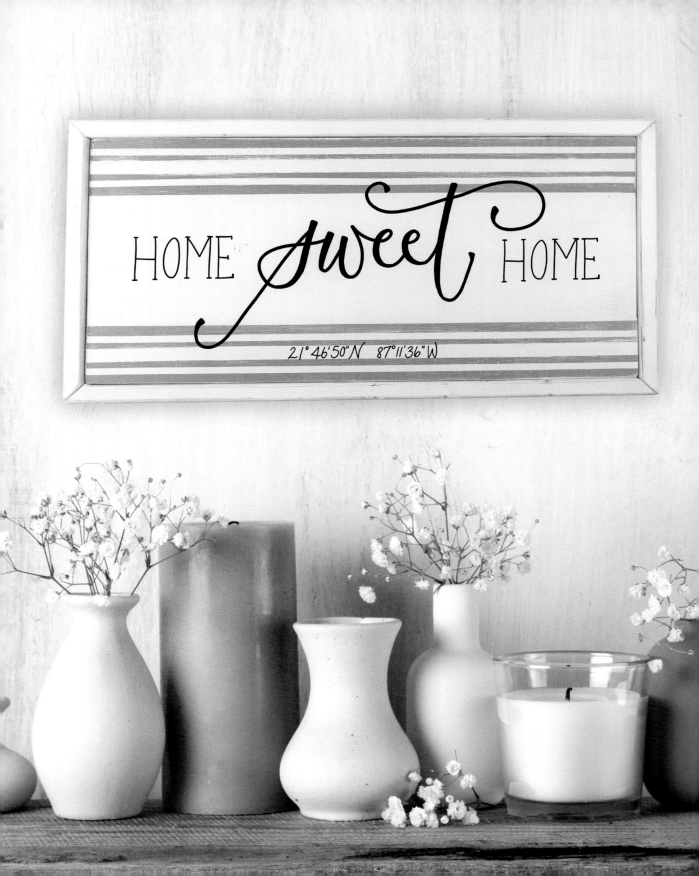

HOME SWEET HOME

Moving is a perfect occasion for giving a hand-lettered wood sign. What a special housewarming gift to feature a well-loved phrase like "Home Sweet Home" and then personalize it with the coordinates of the new home! The stripe design complements a wide variety of home decor styles, so you can gift with confidence that this sign will look beautiful in its new home.

SUPPLIES

- Orbital sander, with medium- and fine-grit sanding discs
- 4 furring strips for frame, mitered edges, cut to surround the edges (see diagram at right)
 - 2 cut to 20½" shortest corner to corner
 - 2 cut to 10" shortest corner to corner
- Tack cloth
- Paintbrush or paint roller
- Primer
- Fine- and medium-grit sandpaper, for hand sanding
- White indoor latex paint, flat
- Common board, 1" x 12" x 18"
- Painter's tape
- Olive (or color of your choice) indoor latex paint, flat, for line details
- Paper and marker, for practice lettering
- Pencil, for lettering transfer
- Black fine-tip acrylic paint pen
- Black medium-tip acrylic paint pen
- Wood glue
- Bar clamps

- Brad nailer and 1¼" finishing brad nails
- Tape measure
- Large (5" sawtooth hanger, with accompanying nails (optional)
- Hammer (optional)

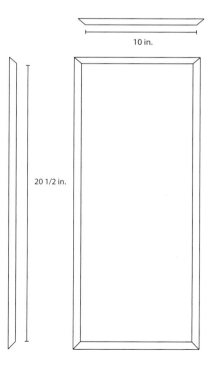

10 in.

20 1/2 in.

DIRECTIONS

1. **PREP THE WOOD:** Using an orbital sander, sand the furring strips with medium-grit and then fine-grit sandpaper. (See technique tips on page 58.) Clean the newly sanded strips with the tack cloth.

2. Using a paintbrush, paint three sides of the furring strips with primer. Allow to dry, according to the directions.

3. Paint the remaining sides of the furring strips with primer and touch up the other sides. Allow to dry, according to the directions.

4. Lightly hand sand the primed furring strips with fine-grit sandpaper. Clean with the tack cloth.

5. Apply a layer of white latex paint on all 4 sides of the furring strips. Set the strips aside to dry.

6. Paint the common board with a layer of primer. (This step will keep the wood grain or knots from bleeding through the white paint.) Allow the primer coat to dry, according to the directions.

7. Using a small roller or brush, apply a layer of white latex paint to the underlayment board. Allow the paint to dry, according to the directions.

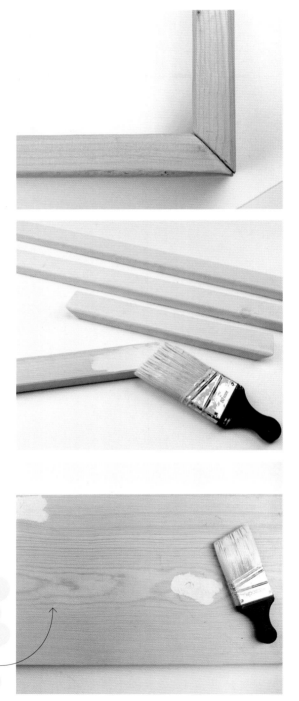

My wood board had two large knots, so I painted a layer of primer just on those, allowed it to dry, and then added a layer of primer over the entire board.

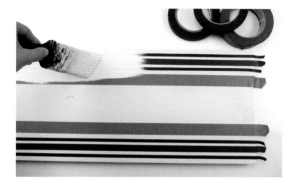

8. **PAINT THE STRIPE DETAILS:** Apply painter's tape and smooth flat onto the board. Paint a layer of white over the tape. Allow the paint to dry.

9. Paint a layer of olive paint (or the color of your choice) over the tape.

10. Gently peel off the painter's tape while the colored paint is still wet. Allow the paint to dry before lettering.

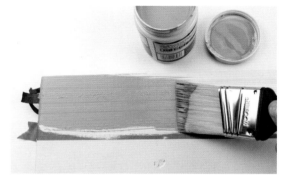

Applying a layer of paint the same color as the background will ensure that the painted lines don't have any bleeding under the tape. Be patient and give plenty of dry time between layers to ensure that the painter's tape doesn't pull up your white paint layer.

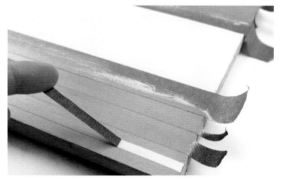

11. **DISTRESS, IF DESIRED:** Fold a piece of medium-grit sandpaper and hand sand over the stripes and edges of the frame. Roughly sand so that the white paint and wood grain show through in different areas.

12. BEGIN THE LETTERING: For a sign like this with a repeat word, use the transfer method described in the introduction (see page 66). On a piece of paper, using a combination of Faux Calligraphy and Block Print, write "Home" and "Sweet" exactly as you would like the lettering to look on the sign.

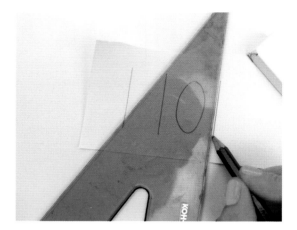

13. Flip the practice sheet over and darken the back completely with pencil. Flip the lettering back over and place on the sign. Use painter's tape to secure in place. With the pencil, trace over the letters slowly and firmly. This method will transfer the letters to the wood. Remove the paper and trace over the letters with the medium-tip paint pen.

I wrote "home" once but will place it on the sign board two times for the transfer. This way, the words will look as identical as hand lettering gets!

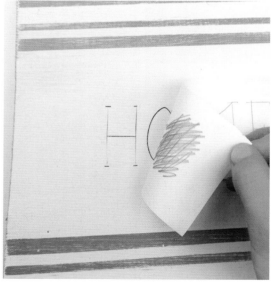

14. Repeat the transfer and paint process for adding the home coordinates, using the fine-tip paint pen. Allow the paint to dry and add one more coat of paint over the lettering.

Home coordinates can be found using Google Maps.

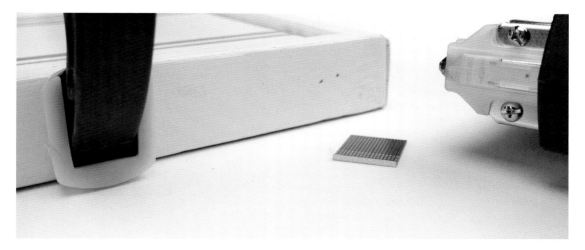

15. **FRAME THE SIGN:** Apply wood glue to the furring strips. Attach the strips along the sides of the sign board. Use bar clamps to secure in place across the sign. Use the brad nailer to add three finishing nails along each stretch of frame, connecting the sign board to the furring strips. Clean up any glue that might squeeze out with a damp rag.

16. **ADD HANGING HARDWARE:** You can choose to simply hang the sign on the "lip" of the frame. But if you would like to add a sawtooth hanger, use a tape measure to find and mark the center of the top furring strip. Center the sawtooth hanger horizontally on the furring strip. With a hammer, carefully tap the two small nails into the strip.

MIX IT UP

A. Mix "home" in Faux Calligraphy with "sweet" in Cafe Print.

B. Switch "home" to Cafe Print and "sweet" to monoline Faux Calligraphy.

C. Design "home" in Block Print and "sweet" in Faux Calligraphy with a capital letter *S*.

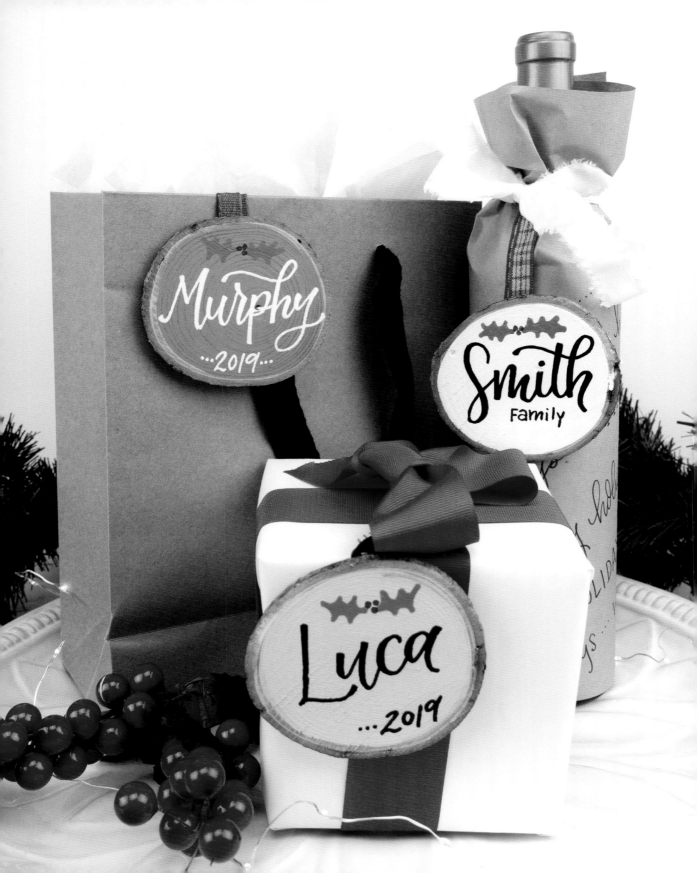

A SLICE OF CHARM

Part of my holiday prep involves painting a stash of wood slices. They make perfect gifts that can be quickly personalized! Some of my favorite ways to present them: with first names for stocking tags or with family names for tree ornaments and wine toppers. These homemade accents also look beautiful on top of cookie plates for neighbors, teachers, and coworkers. How will you use them this upcoming holiday season?

SUPPLIES

- Wood slices
- 2 small 1" paintbrushes
- Primer
- Fine-grit sandpaper
- Tack cloth
- Indoor flat latex paint in your choice of colors (I use white, light gray, and dark gray.)
- Chalk in a color that contrasts with the latex paint (optional)
- Pencil and scrap paper, for practice lettering (optional)
- Fine-tip acrylic paint pen in your choice of colors, for lettering
- Microfiber cloth (optional)
- Medium-tip acrylic paint pens in your choice of colors, for additional art
- Scissors
- 4" ribbon, assorted colors and patterns
- Hot glue gun

DIRECTIONS

1. **PREP THE WOOD:** Paint each wood slice with a layer of primer. Allow the primer coat to dry, according to the directions.

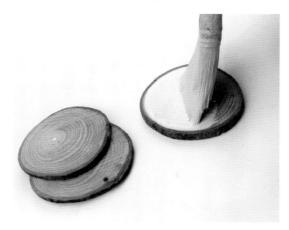

2. Lightly sand the primed surface by hand to smooth out any small bubbles or bumps. Clean with the tack cloth.

3. Apply a layer of latex paint. Allow the paint to dry, according to the directions.

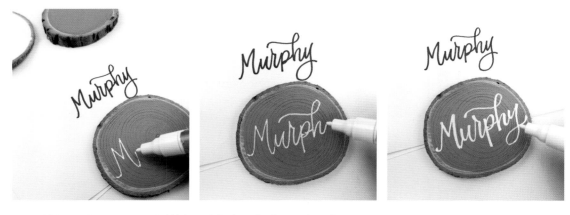

4. **BEGIN THE LETTERING:** Write with the chalk on the slice to plan the lettering, or write on a practice sheet and place above the slice.

I prefer the latter method for small projects, but either way works.

5. Following your chalk guides or practice sheet, write on the wood slice with a paint pen. Allow the paint to dry completely to the touch. If you used chalk guidelines, erase them with a damp microfiber cloth.

6. "Double up" your downstrokes (see the technique on page 7). Allow the coat of paint to dry, then write over the letters with a second coat for opaque letters.

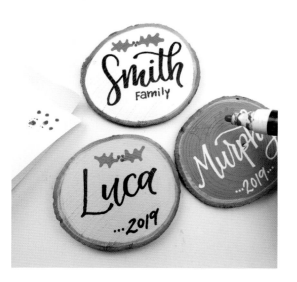

7. **DESIGN THE EMBELLISHMENTS:** For a simple pop of color, add holly to the slices. Start with an outline of the holly leaves, then fill them in with a green paint pen. After the green paint has dried, add three dots with a red paint pen. Use the design at direction as inspiration or add your own accents in colors of your choice.

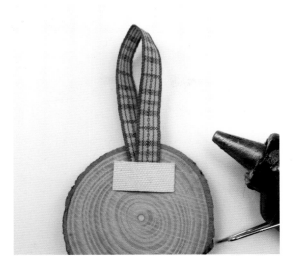

8. **ADD HANGING RIBBON:** Cut a length of ribbon 4 inches long. Use the hot glue gun to glue the ends of the ribbon to the back of the wood slice, creating a loop. Allow the glue to cool before pulling on the ribbon.

Place a piece of scrap cloth over the glued ends. This little trick allows you to place pressure directly on the glued spot without burning your fingers and also makes a more finished back

MIX IT UP

A. Try gluing three white wood slices together to create these fun snowmen. They make great family name ornaments!

B. Make a mini version of the Focus on Joy project (page 169) as a wood slice!

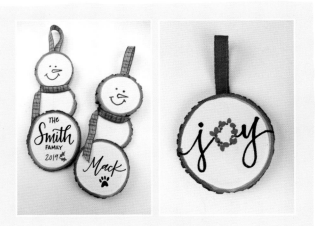

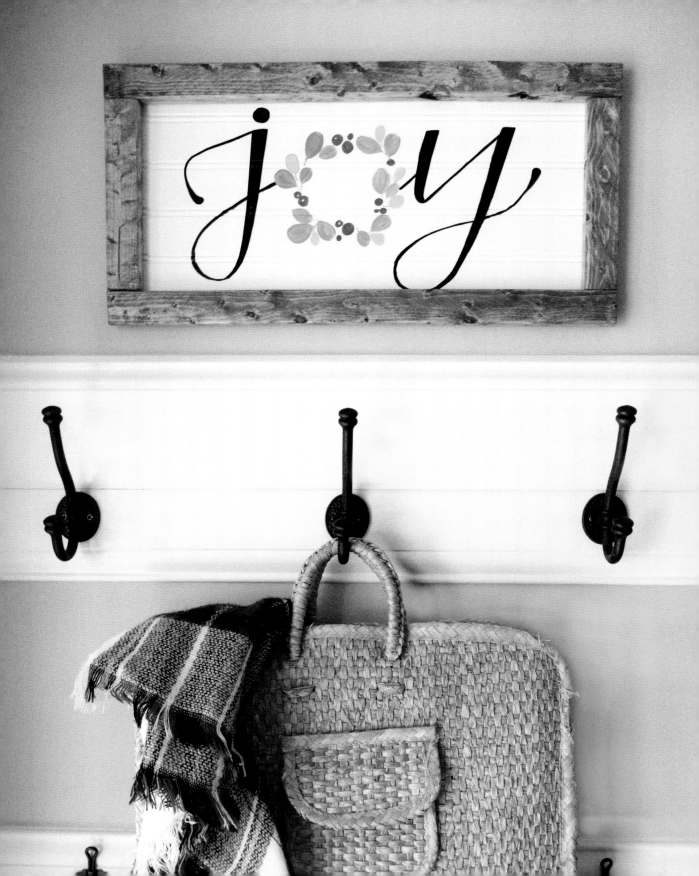

FOCUS ON JOY

"Joy" has always been a word that resonates with me. It's a great focus for the holiday season, when everything can get chaotic—a reminder to treasure the gifts of the heart. This sign captures the sentiment in a bit of an irregular size. I designed it to swap out a mirror that hangs above our entryway hooks the rest of the year. Feel free to design your own custom-size sign that fits into a special spot in your home and makes it easy for a seasonal swap with your existing decor. A simple joy and the beauty of DIY!

SUPPLIES

- Orbital sander, with medium- and fine-grit sanding discs
- 2 furring strips, 22¼"
- 2 furring strips, 8¾"
- Tack cloth
- Microfiber cloth, for stain application
- Minwax Early American stain (or stain of your choice)
- Paper and marker, for practice lettering
- Pencil, for lettering transfer
- Beadboard panel, 22" x 11"
- Painter's tape
- Black medium-tip acrylic paint pen
- Black fine-tip acrylic paint pen
- Acrylic paint in 3 colors, for wreath (I chose a bright true red and two whitish greens, one with much more white for the outside leaves.)
- Wood glue
- Spring clamps
- Brad nailer and ⅝" finishing brad nails
- Tape measure
- Large (5") sawtooth hanger, with accompanying nails
- Hammer

DIRECTIONS

1. **PREP THE WOOD:** Sand the furring strips with medium-grit and then fine-grit sandpaper. (See technique tips on page 58.) Clean the newly sanded strips with the tack cloth.

2. Using the microfiber cloth, apply the stain to the front, sides, and ends of the furring strips, following the wood grain. Allow the stain to dry, according to the directions.

3. **BEGIN THE LETTERING:** For a sign like this with minimal text, use the transfer method described in the introduction (see page 66 for a refresher). On a sheet of paper the same size as your sign, write the *j* and *y* in Faux Calligraphy exactly as you would like the lettering to look on the sign.

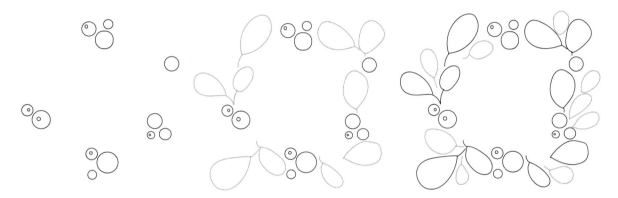

4. Sketch the wreath for the *o*. Begin with large and small berries in a mix of clusters and singles, marking your round shape. Next, fill in with large rounded leaves. Finish with smaller leaves. Try to keep your clusters irregular—it will keep the eye from fixating on certain spots. Use the design above as inspiration.

5. Flip the outline sheet over, then darken the back completely with pencil. Flip the lettering back over and place on the sign. Use painter's tape to secure in place. With the pencil, trace over the letters slowly and firmly. This method will transfer the letters to the wood.

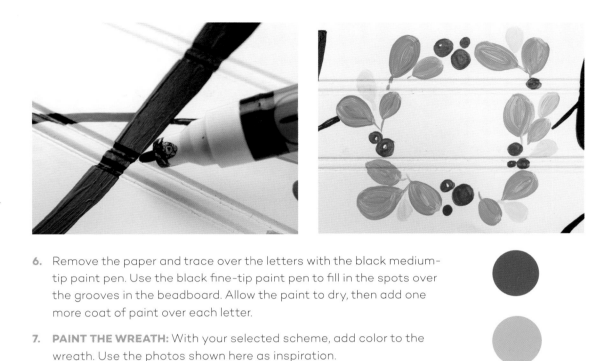

6. Remove the paper and trace over the letters with the black medium-tip paint pen. Use the black fine-tip paint pen to fill in the spots over the grooves in the beadboard. Allow the paint to dry, then add one more coat of paint over each letter.

7. **PAINT THE WREATH:** With your selected scheme, add color to the wreath. Use the photos shown here as inspiration.

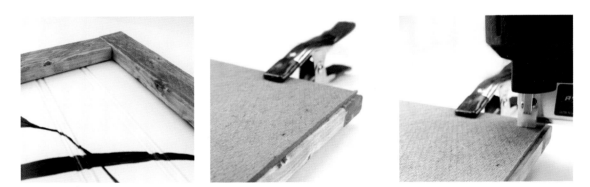

8. **FRAME THE SIGN:** Apply wood glue to the unstained side of the furring strips. Attach the furring strips along the edge of the beadboard sign, creating a border.

9. Clamp the furring strips in place. Once all four pieces are glued and clamped in place, carefully turn over the sign. Use the brad nailer to add three finishing nails, connecting the beadboard to the furring strips. Clean up any glue that might squeeze out with a damp rag.

10. **ADD HANGING HARDWARE:** Use a tape measure to find and mark the center of the top furring strip. Center the sawtooth hanger horizontally on the back of the panel over the furring strip. With a hammer, carefully tap the two small nails into the panel.

MIX IT UP

A. Replace the Faux Calligraphy with Cafe Print.

B. Hot glue a festive ribbon to the top of the painted wreath for more texture.

C. Hot glue a small 6-inch wreath (found at craft stores) to the beadboard to act as the *o*.

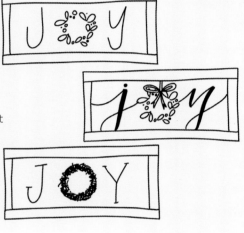